IMAGES
of America
LEONIA

To Tom—
Carol Karels
3-7-02

LEONIA, THE TREEHOUSE. Tree-lined streets have always been a main attraction in Leonia. A booklet published in the 1930s by the Leonia Shade Tree Commission noted that "trees are indeed a gift of heaven but shade trees on our streets are heaven's reward for foresight and care." More than 15,000 shade trees have been planted on Leonia's streets and slopes, making many think of their town as a treehouse. Leonians have always placed great emphasis on recognizing and protecting their trees. The town has been designated a Tree City USA for 12 straight years.

Carol Karels

Copyright © 2002 by Carol Karels.
ISBN 0-7385-0973-6

First printed in 2002.

Published by Arcadia Publishing,
an imprint of Tempus Publishing, Inc.
2A Cumberland Street
Charleston, SC 29401

Printed in Great Britain.

Library of Congress Catalog Card Number: 2001096947

For all general information contact Arcadia Publishing at:
Telephone 843-853-2070
Fax 843-853-0044
E-Mail sales@arcadiapublishing.com

For customer service and orders:
Toll-Free 1-888-313-2665

Visit us on the internet at http://www.arcadiapublishing.com

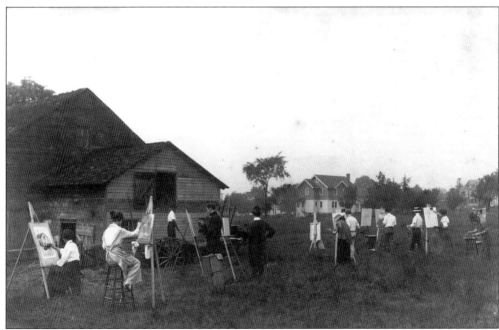

AN ART SCHOOL FOR AMATEURS. For nearly half a century, Leonia was a noted art colony—home to more than 90 professional artists. To accommodate the influx of artists in training, barns and lofts were converted into studio space throughout town. In addition to the Leonia School of Illustration for professional artists, an art school for amateurs was also popular with talented housewives, who are shown here painting in a field.

CONTENTS

Acknowledgments 7

1. Early Leonia 9

2. Leonia Landscapes 37

3. Leonia Life 77

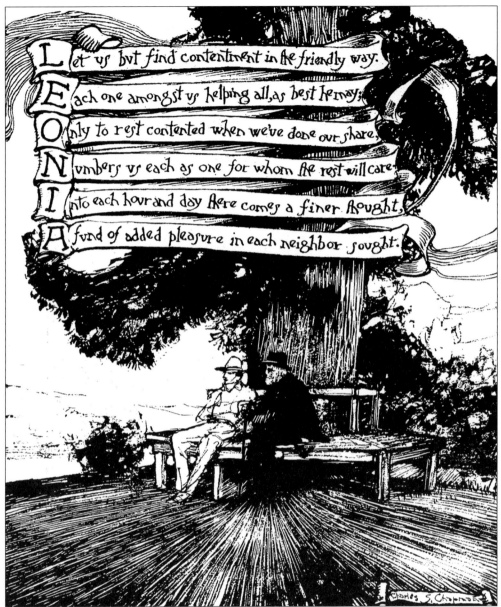

THE LEONIA MEN'S NEIGHBORHOOD CLUB, 1916. The Leonia Men's Neighborhood Club met monthly to promote friendship, harmony, and discourse among Leonians. Club member Charles Chapman, an artist and wordsmith, summarized the club's spirit of community with this poem and drawing. In 1922, Chapman was also a leading proponent of the Community House, which was later developed to serve as a gathering spot and central meeting place for Leonia volunteer organizations.

ACKNOWLEDGMENTS

First and foremost, thanks go to library volunteer Lee Lehman, who, since 1993, has diligently and thoughtfully arranged, itemized, and labeled the items in the Leonia Public Library Local History Collection. She assisted me throughout the preparation of this book.

Special thanks go to Joel Lee Groves for scanning the materials and saving them electronically as we removed them from the collection, so that future generations of Leonians will be able to access this historical material on-line. Thanks go to former library director Harold Ficke and the Leonia Public Library Board of Trustees for having the foresight in 1987 to hire a professional archivist, Gail Malmgreen, to catalog the historical photographs and documents that had been donated over the years. I also want to thank the library staff, especially director Deborah Bigelow and reference librarian Teresa Wyman, for their cooperation. Thanks go to colleague Kevin Tremble of Tech-Repro for his critical eye and for providing the means to create high-quality reproductions of these photographs for public exhibits.

Thanks go to all the Leonia residents, past and present, who enthusiastically chronicled Leonia's history in words, photographs, maps, or art. These include David Boyd, Charles Chapman, Anna Noyes, Paul Mattingly, Carole Root Cole, Nancy Hawkins, Virginia Kiehl, Martha Rado, Carmey Cross, and Dr. Arthur Hixson.

Thanks go to all the Leonians who lent their photographs and historical postcards, including the Oliver family, the Chace family, Harriette Coleman, Muriel Coles, Harriet Hoenie, the Minerly family, Paul Olson, Maureen Havlusch, Pat Millet, Karen Raucci, Barbara Reynard Dey, Cay Shedd, Sidney Unsworth, Dia Pines, and Mary Kryhoski Slutz. Thanks go to the Leonia League of Women Voters for granting permission to use images from its historical artist's note card collection, to the Players Guild of Leonia, to the Leonia Ambulance Corps, and to all the other Leonia organizations that helped with this book. Thanks go to Paul Mattingly, Harriet Hoenie, and David Boyd and Barbara Marchant of the Leonia Historic Preservation Commission for reviewing the text for accuracy. Thanks also go to my daughter Beth and to Mary Ann Groves for helping me identify "unidentified" dwellings in town.

Finally, I am grateful to the residents of Leonia for contributing the funds necessary to renovate the Leonia Public Library in 2000, enabling us to relocate the local history and art collection from the janitor's closet into a more spacious, well-equipped, climate-controlled Local History Room.

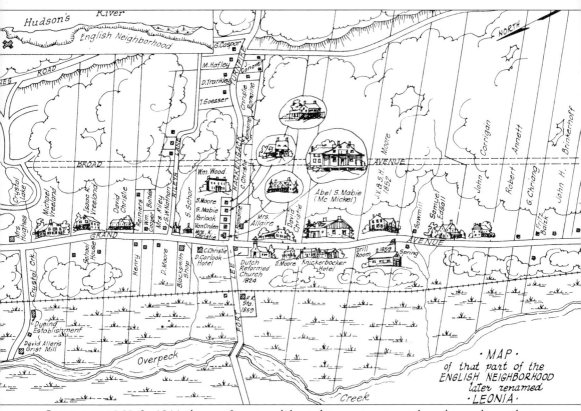

LEONIA IN 1869. In 1944, the year Leonia celebrated its semicentennial as a borough, residents not serving overseas in World War II prepared a commemorative book on Leonia's history. In addition, Leonia artist Charles Chapman re-created this map of what Leonia looked like in 1869, a decade after the railroad came, to provide residents with a sense of visual history. The map shows that Leonia was made up of long narrow strips of farmland that ran from the Overpeck Creek to the top of the hill. Names of prominent landholders were Vreeland, Christie, Mabie, Moore, and Allaire. The map also shows the drill hall, a dyeing establishment, a gristmill, a school, and two hotels. Most of the large homesteads that Chapman drew on this map have been destroyed and replaced by apartments.

One
Early Leonia

The peaceful Ashkineshacky Indians, a tribe of the Lenni Lenape nation, were the original inhabitants of Leonia. The first European settlers, of Dutch and English descent, built homesteads in the area in 1668. To the east, over the hill, was the Hudson River; to the west was the Overpeck Creek. Farmers with such names as Vreeland, Cole, and Moore built their stone homes, a church, a schoolhouse, a gristmill, and a sawmill. Most had slaves to help them manage their farms, hunt, and fish. At the time of the Revolution, there were about a dozen farms, a tavern, a blacksmith shop, and stages running north and south on English Neighborhood Road (Grand Avenue). In 1776, Gen. George Washington's army retreated from Fort Lee down the hill through Leonia. Thomas Paine's phrase "the times that try men's souls" described this retreat. Leonia's fertile farms provided sustenance to both armies throughout the war.

Known as the English Neighborhood until 1865, 19th-century Leonia was primarily farmland with ponds, springs, brooks, meadows, apple orchards, barns, stone walls, grazing cows, chickens, and horse-drawn wagons. The town had two cemeteries, including one for slaves. In the early 1800s, reaching New York took half a day, whether by boat down the Overpeck Creek and Hackensack River or by rutted dirt roads and a ferry. The railroad came in 1859, bringing a few newcomers from the city to the area; most were wealthy businessmen who built large homes. A Civil War drill hall was built on Grand Avenue by the Jersey Blues. Leonia men enlisted to fight in the Civil War and in the Spanish-American War. Between wars, residents held military balls, attended dramatic recitals, and played lawn tennis. A village center quickly developed around the railroad station, with stores that provided essential goods such as animal feed, coal, and dry goods. There was also a livery, a post office, and (later) the municipal building.

Growth continued at a slow pace until the end of the 19th century. In December 1894, after much discussion and dissension, the town fathers voted to become a borough. A mayor and council were elected, along with a board of education. Early on, it was agreed that Leonia would primarily be a residential community. Borough boundaries were drawn up, as were ordinances that included deed restrictions on buildings and excluded taverns and funeral parlors within Leonia's borders. A volunteer fire department was formed in 1898, and marshals were hired to patrol the town. At the turn of the century, artists with paint boxes and easels in hand took day trips to the area, via the ferry and trolley, and eventually settled here. Early artists who lived in Leonia included Richard Pauli, Peter Newell, and Harry Eaton, who was the president of the American Watercolor Society. Word spread among artists of the bucolic nature of Leonia, and a thriving art colony soon developed.

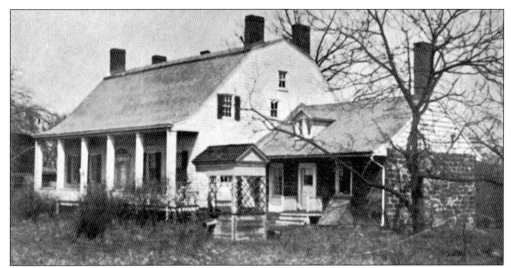

THE VREELAND HOUSE, 125 LAKEVIEW AVENUE. The Vreeland House is among Leonia's oldest homes. The stone wing dates from c. 1786 and the frame portion from c. 1810. The house was built in a style that was typical of the last and finest phase of the Dutch Colonial Federal period, a rare and unique type of American architecture. It was named one of the nation's historic sites on November 17, 1978. The Vreelands lived in Leonia until 2000.

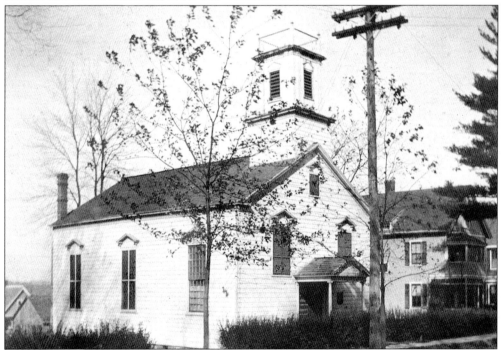

THE CHRISTIAN REFORMED CHURCH. This is Leonia's second church. It was built in the 1820s on ground donated by Garrett Myers and John Cole, on the west side of Grand Avenue, south of Fort Lee Road. Most of Leonia's early residents attended this church and were buried in an adjacent cemetery. Strangers could be buried in the cemetery for $2. The church disbanded in 1898. The building was razed by the Work Projects Administration (WPA) in 1933 to provide work for the unemployed.

NEGOTIATIONS WITH CHIEF ORATAM. Leonia artist Howard McCormick painted this six-by-eight-foot gesso mural depicting negotiations between Hackensack Indian chief Oratam and Peter Stuyvesant, with Sarah Kierstede serving as translator. Oratam was the primary negotiator between the settlers and the Native American tribes. Out of gratitude for Kierstede's services, Oratam gave her more than 2,000 acres in the vicinity of Leonia and Teaneck. The mural, which was painted in 1936 as part of a WPA project, is in the Anna C. Scott School auditorium.

THE ASHKINESHACKY INDIANS. About 1,000 Ashkineshacky Indians lived in the Leonia vicinity before Europeans arrived. They were peaceful farmers, fishermen, and hunters. In the spring, they planted crops. In the summer, they paddled their canoes down the Hackensack River to Staten Island to collect shells for making wampum. In the fall, they held steam bath festivals along the Overpeck Creek. In the winter, the Ashkineshacky retreated to a fort in Palisades Park. (Drawing by Enos B. Comstock.)

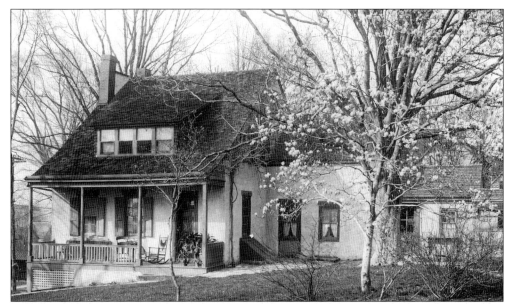

THE COLE-BOYD HOUSE, BEFORE RENOVATION. Built c. 1765 at the corner of Prospect and Grand, this is Leonia's oldest home. It was the original home of loyalist Samuel Cole. In 1885, the house and its 72 acres were sold to Andrew Bogert, a contractor and builder. Bogert subdivided the land into 56 lots, which led to the development of Leonia's first planned neighborhood, Leonia Park. The house is seen here from the south in the early 20th century, when it was known as the Allaire House.

THE COLE-BOYD HOUSE, AFTER RENOVATION. In 1916, artists J. Rutherford and Harriet Repplier Boyd purchased the historic house. Using recycled sandstone from demolished homes, they built a 20-by-30-foot art studio as an east wing. They changed the orientation of the house, built a stone wall (made with stones from three demolished homes), and landscaped the backyard with sunken gardens, fish ponds, and exotic shrubs. Festive parties were held regularly at Boydsnest, as it was called. Four generations of Boyds have lived in the house, including the artists' son David Boyd, an artist himself. (Drawing by David Boyd.)

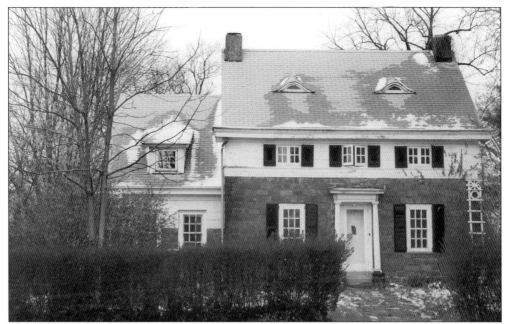

THE SECOND MOORE HOUSE, 215 FORT LEE ROAD. The Moore family was one of the most prominent in early Leonia. The Moores were active in local politics and military events throughout the 19th century. Ancestor Samuel Moore, an English merchant who emigrated from Barbados, bought 175 acres in present-day Leonia in 1726. The first Moore home was destroyed, and this second Moore house was built c. 1815.

THE WOOD MANSION. In 1849, a New Yorker named R.J.G. Wood purchased land in the center of Leonia through a sheriff's sale and built this home. In 1923, the town, under Mayor John Pollock, purchased the house and property to be used for municipal offices, the police station, and the library. The surrounding land became Leonia's first park, Wood Park. The Wood mansion was torn down in 1969, after the new library was constructed.

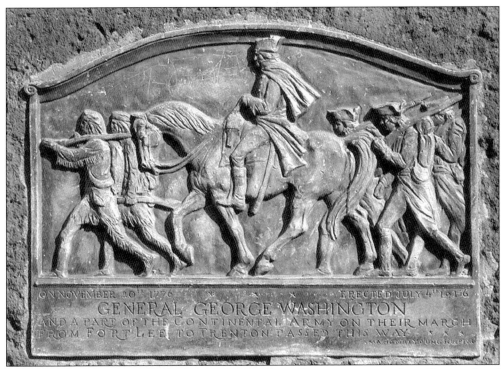

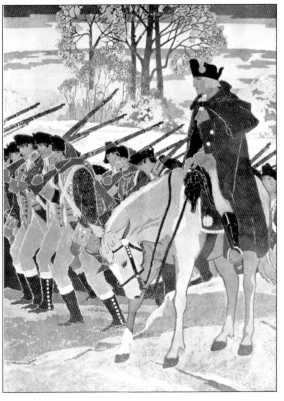

COMMEMORATIVE ART. Two works of art commemorate Gen. George Washington's retreat through Leonia on November 20, 1776. Famous sculptor Mahonri Young, a longtime Leonia resident and grandson of Mormon prophet Brigham Young, designed the bronze tablet (above), which was placed in front of the Leonia Presbyterian Church. The tablet was erected on July 4, 1916, and was given to the town by the Men's Neighborhood Club. In 1936, Leonia artist Howard McCormick painted the retreat (left) as part of a WPA project. The gesso mural hangs in the Anna C. Scott School auditorium. (Photograph by Lisa Lehman Trager.)

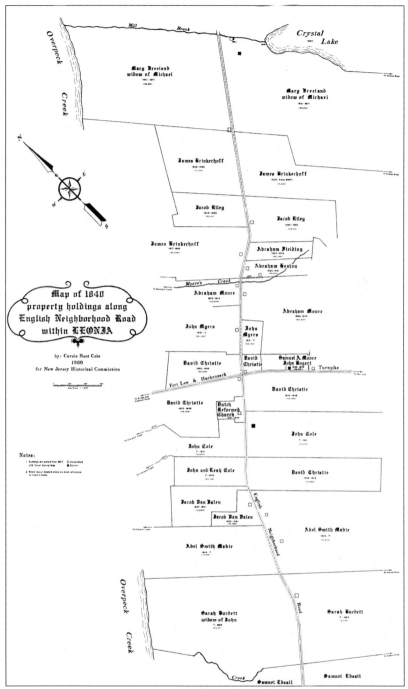

THE CAROLE ROOT COLE MAP OF LEONIA, 1840. This map shows the property owners along English Neighborhood Road in 1840. Note the variety of ethnic traditions in the residents' names—Riley, Van Valen, Cole, Bogert, Moore, Christie, Burdett, and Mabie. Today, the same map would include names such as Kim, Alvarez, Chen, Khan, and Patel, as more than 40 languages are spoken in Leonia's homes. In 2000, 12 percent of the population was Hispanic and 32 percent was Asian. (Courtesy of Carole Cole Neubauer.)

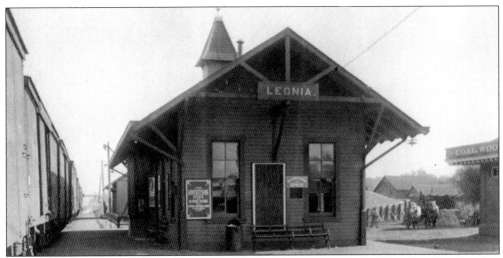

THE NORTHERN RAILROAD. Trains came to Leonia in 1859, bringing Leonia's first commuters—wealthy businessmen who built large mansions. This 1880 station, on the north side of Fort Lee Road and east of the tracks, replaced an earlier building. It was demolished in 1918 when an elegant new station was built at Station Parkway. A village developed around the railroad; there was a general store, a coal yard, a livery, a blacksmith shop, and a store that sold grain, feed, and hay.

> "LEONIA"
>
>
>
> *At a meeting of the residents of the neighborhood on the east of the Overpeck Creek and near to the Station, hitherto known as Fort Lee, on the Northern Railroad of New Jersey, on Monday, the thirteenth day of November instant, it was unanimously resolved to adopt the name of* **"LEONIA"** *for said neighborhood.*
>
> *Dated—November 14, 1865.*
>
> **J. VREELAND MOORE, Pres't.**

THE NAMING OF LEONIA. In 1865, Leonia was a village in Hackensack Township known as Fort Lee at English Neighborhood. The town up the hill was known as Fort Lee on the Hudson. In order to eliminate confusion and to establish a unique identity, a handful of town fathers agreed on the name Leonia, which means "at the foot of Lee," with Lee being Gen. Charles Lee of Revolutionary War fame.

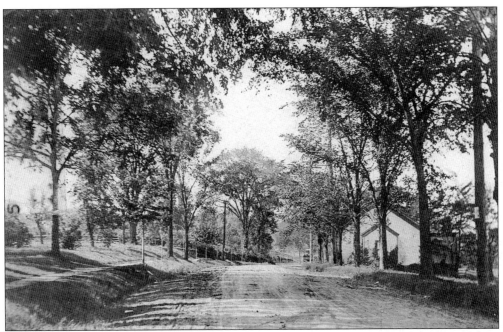

THE CIVIL WAR DRILL HALL, 130 GRAND AVENUE. Built in 1859 by the Jersey Blues (a local volunteer militia), this is the last remaining wood-frame Civil War drill hall in America. It was used for military drills until 1910. Between wars, it served as a community social hall and was later used as a carpenter and millwork shop. In 1961, the English Neighborhood Historical Society acquired the drill hall and invested $30,000 into renovations to make it a Civil War museum. Just weeks before it was to open, the building was damaged by a fire and was abandoned. In 1976, it was placed on the New Jersey and the National Register of Historic Places. In 1993, it became the new home of the Players Guild of Leonia, who renamed it the Civil War Drill Hall Theatre.

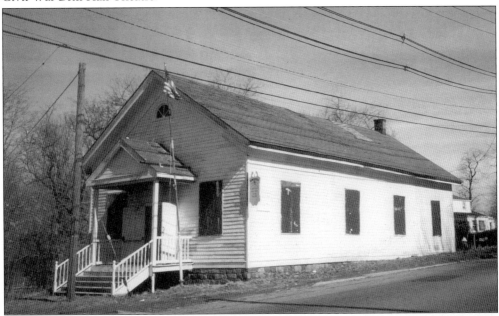

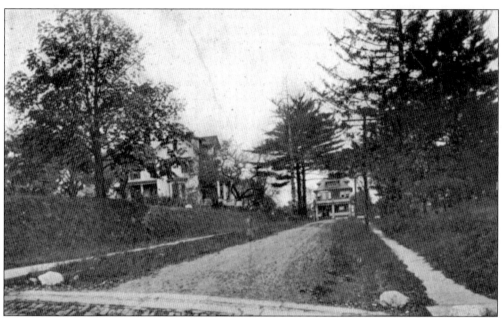

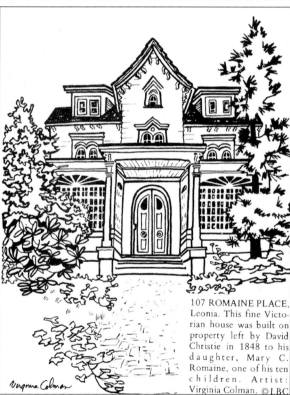

ROMAINE PLACE AND THE ROMAINE HOUSE. Members of the Romaine family were among the first wave of investors who bought land in Leonia around the time the railroad was built in 1859. They purchased a huge six-lot tract of land from the Christie family. In 1860, Mary Christie Romaine, the eldest daughter of David Christie, built this Victorian Italianate house, which is the only one of its type in Leonia. Today, the house has been subdivided into apartments. (Drawing by Virginia Colman.)

107 ROMAINE PLACE, Leonia. This fine Victorian house was built on property left by David Christie in 1848 to his daughter, Mary C. Romaine, one of his ten children. Artist: Virginia Colman. ©LBC

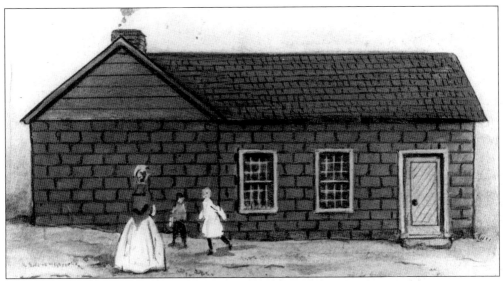

LEONIA'S FIRST SCHOOL. This sketch by artist Peter Newell shows Leonia's first school, located on Grand Avenue. Built in 1845, it was used throughout the Civil War years. Records show that for 18 years, from 1859 to 1877, Fred Bennett was the sole teacher for 66 students. Students ranged in age from 5 to 16. Tuition was $6 per year. School was held year-round, but many students took time off to pick strawberries in the early summer. Peter Newell was one of the first artists to move to Leonia. He illustrated children's books, including *Alice in Wonderland*, and was considered the Walt Disney of his time.

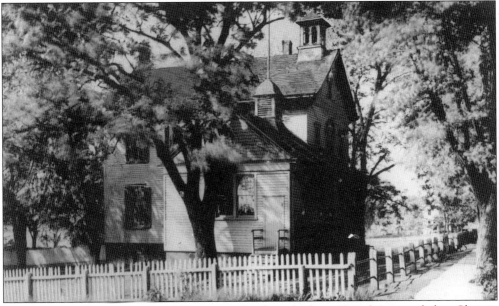

AN EARLY SCHOOLHOUSE. In 1880, a new school was built on Grand Avenue below Christie Heights Street. It had a separate entrance for girls and boys, and there were outhouses behind the school. As enrollment increased and the physical conditions of the school declined, newcomers demanded that a new school be built. They complained about flooding, unsanitary latrines, and the noise from the constant traffic on Grand Avenue. The school board, formed in 1895, agreed to build a new school in 1904.

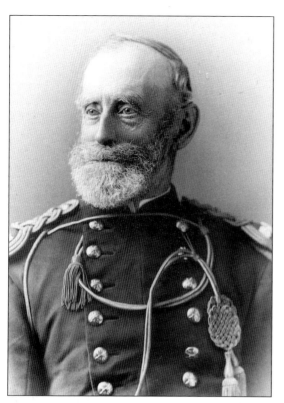

J. Vreeland Moore, c. 1895. A brigadier general of the Jersey Blues, J. Vreeland Moore lived in Leonia for more than 50 years. He was a member of the first council formed when Leonia organized as a borough in 1894, and he served as council president for two terms. He died in 1903 at the age of 79.

A Military Lawn Party, 1883. Long after the Civil War was over and 15 years before the Spanish-American War began, Leonians continued to have formal military balls and lawn parties, usually hosted by the Moore family. These balls were held at the Moore Homestead on Moore Avenue or at the armory across the street. Formal invitations, such as this one, were sent out for many occasions.

Captain, and the Misses Moore request the pleasure of your company, at eight o'clock, on Friday Eve, August 17, 1883, "weather permitting," at a

Military Lawn Party,

Complimentary to "Fair" Ladies, and Co. A.

"Frame your mind to mirth and merriment,
Which bars a thousand harms, and lengthens life."

Stephen H.V. Moore, c. 1895. This Moore family patriarch was a prominent citizen in the 19th century. He was active in county and local politics most of his life. He helped organize the local unit of the Jersey Blues militia and held the rank of colonel. He died in 1911, at the age of 83. He served on the board of freeholders for nine years in the late 1880s. His grandson, Harry E. Moore, carried on the family tradition and became mayor in 1928.

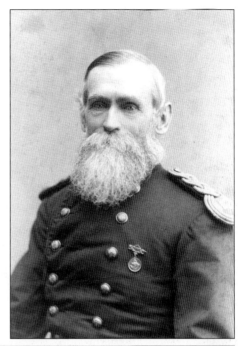

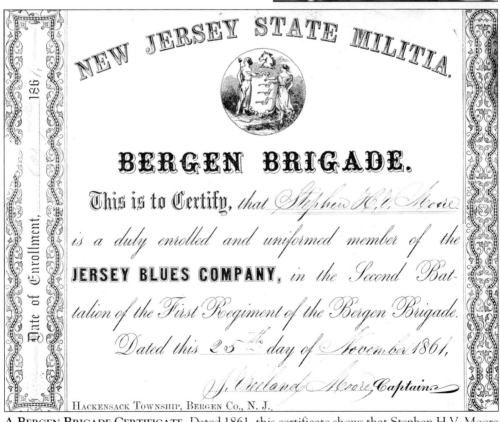

A Bergen Brigade Certificate. Dated 1861, this certificate shows that Stephen H.V. Moore of Hackensack Township was a captain in the Jersey Blues.

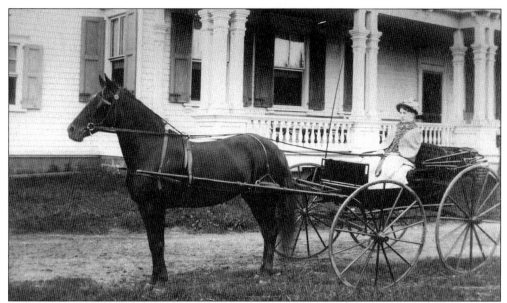

HENRIETTA MOORE AND CARRIAGE. Henrietta Moore is shown in front of the Moore Homestead c. 1900. Horses were a common sight, sound, and smell in Leonia before the advent of the automobile. Horses pulled carriages, surreys, wagons, sleighs, and phaetons. The horse and wagon was used to deliver ice, fruits and vegetables, and milk. A number of families in town had coachmen.

THE OLD MOORE HOMESTEAD, 1896. This is the third Moore Homestead in Leonia, a Civil War–era Victorian structure on the southeast corner of Moore and Grand. Leonians played tennis on the lawn and had social functions and dances across the street at the armory. Later, in 1914, famous artists Charles Chapman and Harvey Dunn purchased the home for their Leonia School of Illustration, which thrived until 1920. The homestead burned down in 1939.

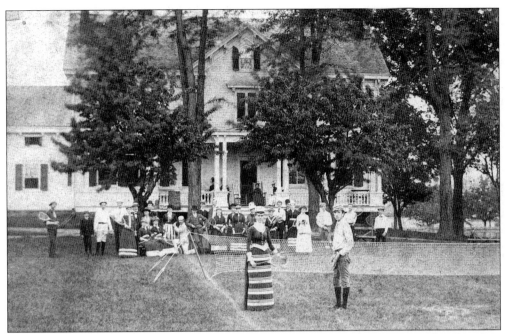

LAWN TENNIS, 1887. Lawn tennis was a favorite sport among early Leonians, who played on the grass courts in front of the Moore Homestead on lower Moore Avenue. In 1894, the courts were converted to dirt. In 1910, after new courts were built on the lot adjacent to the home, the Oakdene Tennis Club was formed. It later became the Leonia Tennis Club.

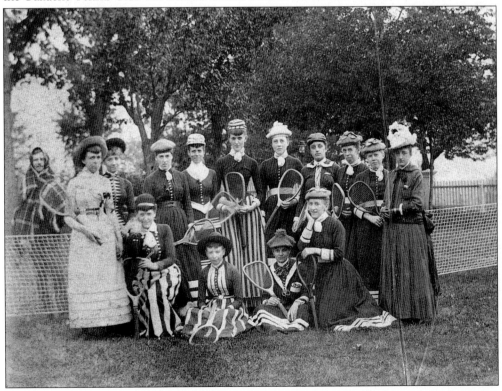

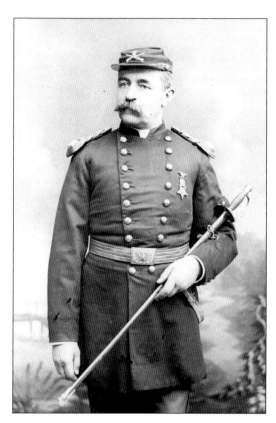

EMANUEL GREGORY GISMOND. In 1850, at the age of 14, Emanuel Gismondi (later Gismond) emigrated from Italy. The youngest of 11 children, he refused to return to his wealthy family in Genoa, so enchanted was he by the new world. He apprenticed with blacksmith George Schor in Leonia, served in the Civil War, started a coal business, and served as a school trustee. He helped pave Grand Avenue with macadam taken from numerous stone fences in the area. He was also the first Leonian to implement streetlights, after placing an oil lamp on a high pole in front of his home.

LOUISE SCHOR GISMOND. Born in 1839, Louise Schor married Emanuel Gismond, who was apprenticed to her father in Leonia. They built a homestead on Grand Avenue and had nine children. When the youngest child was only five, she and her husband died of typhus within days of each other. Many of their children were active in Leonia's organizations, politics, and schools. Their daughter Rebecca was the town schoolteacher.

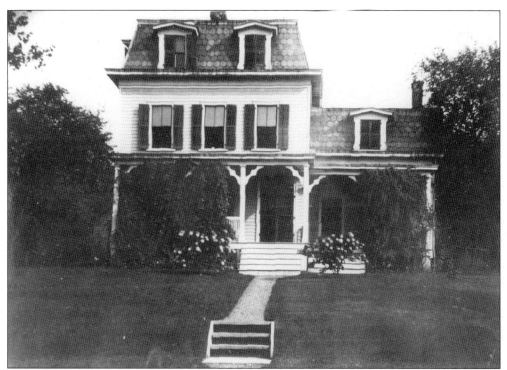

THE GISMOND HOMESTEAD, 401 GRAND AVENUE, 1871. This was the home built by Emanuel Gismond for his growing family. The mansard roof made this Victorian-style house unique in Leonia. The home still stands.

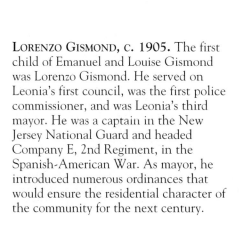

LORENZO GISMOND, C. 1905. The first child of Emanuel and Louise Gismond was Lorenzo Gismond. He served on Leonia's first council, was the first police commissioner, and was Leonia's third mayor. He was a captain in the New Jersey National Guard and headed Company E, 2nd Regiment, in the Spanish-American War. As mayor, he introduced numerous ordinances that would ensure the residential character of the community for the next century.

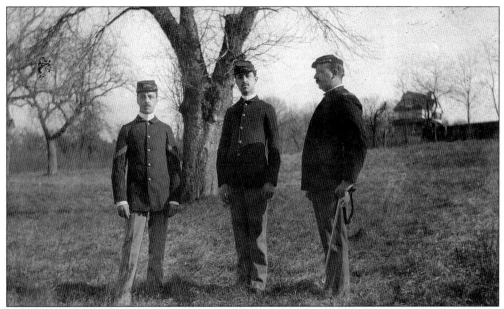

THREE GISMOND BROTHERS, 1895. Shown from left to right are three of the five Gismond brothers—Emanuel Jr., James Christie, and Lorenzo—behind the family home at 401 Grand Avenue. All are dressed in their New Jersey National Guard uniforms. All were active in Leonia politics. It was Lorenzo who first heard of Palisades Park's secret plan to become a borough with the northern border being Fort Lee Road. He alerted fellow Leonians, who thwarted the plan.

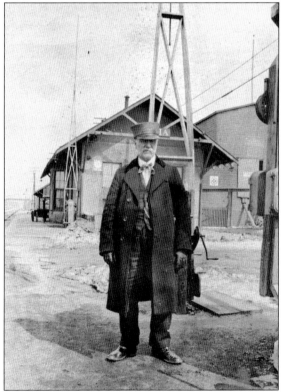

CORNELIUS "SQUIRE" SCHOR, c. 1895. C.D. Schor wore many hats in early Leonia. He served as stationmaster, bridge tender, postmaster, general store owner, auctioneer, justice of the peace, real-estate agent, and dentist (untrained, he offered to pull teeth for a quarter). After Leonia became a borough in 1894, he also served as the first tax assessor. Schor Avenue, named after his family, was the last to be paved in Leonia, remaining a dirt path until the 1980s.

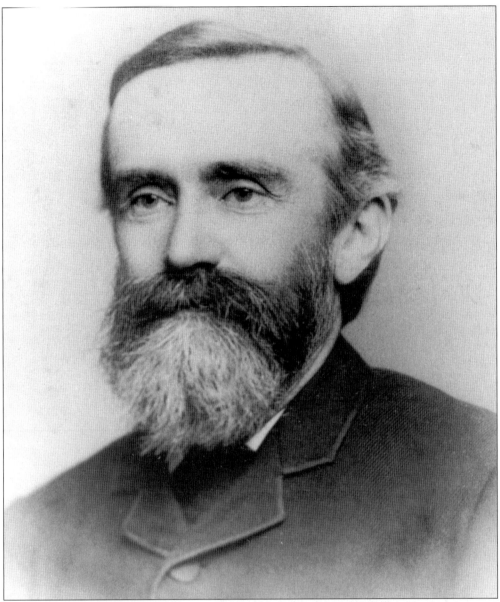

LEONIA'S FIRST MAYOR. Cornelius Christie was the first mayor to be elected after a borough form of government was established on December 5, 1894. A lifelong bachelor, Christie was born and raised in Leonia, the eldest of David Christie's 15 children. He studied at Yale and Harvard. His brother Nicholas was one of four men who chose the name Leonia in 1865. His sister married millionaire Leonia developer Edward Stagg. In addition to Christie's law practice, he was a newspaper publisher, a state legislator, and a land developer. In 1894, he heard from Lorenzo Gismond that Palisades Park had a secret plan to file papers to become a borough, a plan that included Fort Lee Road as the northern border. Leonia had recently voted against becoming a borough. Christie called an emergency town meeting and explained what Palisades Park intended to do. This time, the men voted in favor of a borough government. Cornelius Christie drafted the legal papers in the middle of the night, and a messenger raced across the meadows to Hackensack in the morning, spoiling Palisades Park's plan to annex half of Leonia.

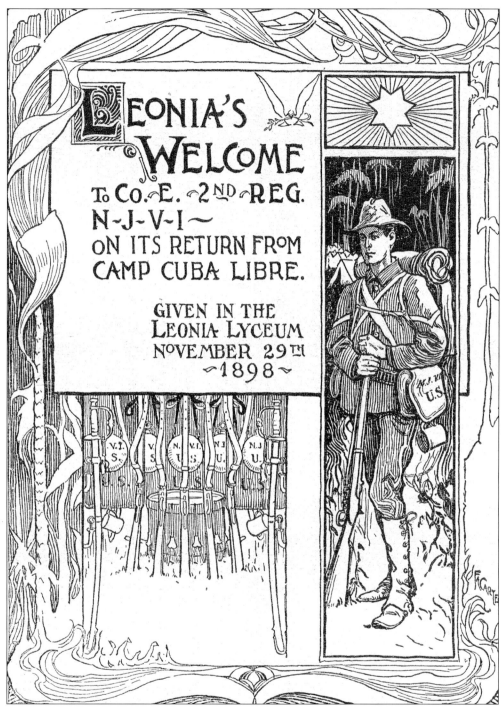

A Reception for Soldiers. On November 29, 1898, Leonians held a gala homecoming reception for members of Company E, 2nd Regiment, who were returning from training at Camp Cuba Libre in Florida. Although Company E never received orders to sail to Cuba to fight in the Spanish-American War, letters home mentioned fierce battles with the Florida mosquitoes. Leonia artist Freeman A. Carter designed this program.

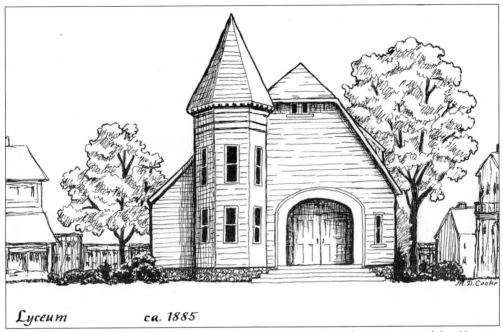

Lyceum ca. 1885

THE LEONIA LYCEUM. In the 1890s, theater played a big role in the community life of Leonia and the growing nation. Lyceums, such as this one on Fort Lee Road opposite Spring Street, opened up along the East Coast to host visiting lecturers and entertainers. The Leonia Lyceum was also the birthplace of the Presbyterian, Methodist, and Episcopalian churches in town. The building lasted until *c.* 1914.

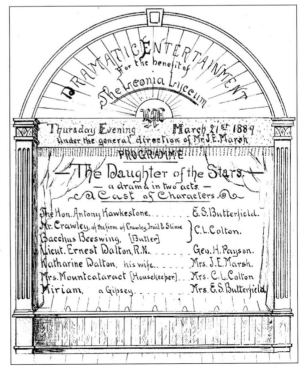

DRAMATIC ENTERTAINMENT, 1889. Shown is a program from the two-act drama *The Daughter of the Stars*. It was presented at the Leonia Lyceum, where charity bazaars, dramatic readings, concerts, playlets, and minstrel shows were frequent fare. Entertainment was provided either by visiting theater troupes or by local thespians, of which there were quite a few. Later, in 1919, the community formed its own theater group, the Players Guild of Leonia.

DRAMATIC ✶ RECITALS.

—BY—

 JNO. J. CAROLAN,

UNDER THE AUSPICES OF THE L. L. L.

AT THE

Armory of Co. A, Leonia, N. J.,

MAY 17, 1887.

PROGRAMME.

Music.—The Misses Moore.

Recitations.—"The Life Boat"..............Geo. R. Sims.
 The Doorstep...................E. C. Stedman.

Music.—Miss Cornelia Gismond.

Recitation.—"The Raven" (A Dramatic Study.) Edgar Allen Poe.

Music.—Cornet Solo, Prof. Sam'l Mabie,
 accompanied by Miss May Campbell.

Recitation.—"Phil. Blood's Leap, A Tale of the Gold Seekers."
 Robt. Buchanan.

Music.—Miss Cornelia Gismond.

Recitations.—"Leedle Yacob Strauss"............C. F. Adams.
 "Luke......................Bret Harte.

Finale——

The Piano used on this occasion is from the Manufactory of C. Roof & Son, Fort Lee, N. J.

THE LEONIA LITERARY LEAGUE. Leonia's first club, the Leonia Literary League, was formed in 1885 for the purpose of "mental cultivation by means of literary exercises." A typical monthly meeting had a poetry reading, vocal and instrumental performances, and a debate or mock trial. At one meeting, the debate topic was "Should husbands consult their wives in business matters?" The bylaws forbade discussion of party politics and sectarian religion. Shown here is a program from 1887.

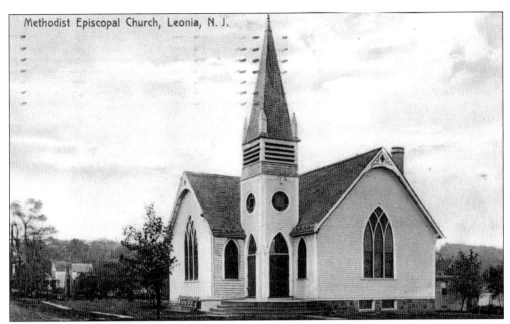

THE METHODIST EPISCOPALIAN CHURCH. This church was formally organized in 1890. Congregants met at the Leonia Lyceum until they built this wooden church on Harrison Street in 1894 on land donated by the Hurd family. In 1913, the Methodists sold the building to the newly formed St. John's Catholic congregation.

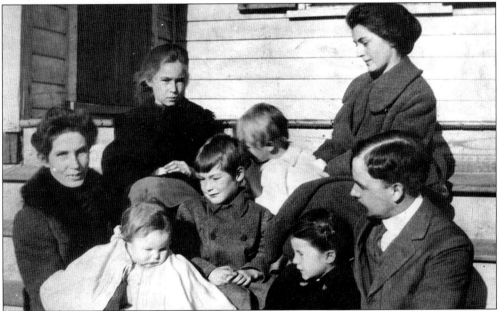

THE BEECHINGS AND THE HURDS, 325 HAROLD AVENUE, C. 1917. The Hurd and Beeching families came to Leonia in the late 1880s. Alfred Hurd was a founder of the Methodist church and served on the first board of education. David Beeching was on the first town council. Seen here are their children, William Hurd and Hattie Beeching, who married and had seven children. Hattie died during the deadly flu pandemic of 1918, leaving her daughter Doris (above right) to help care for her young siblings. Five generations of this family have lived in Leonia.

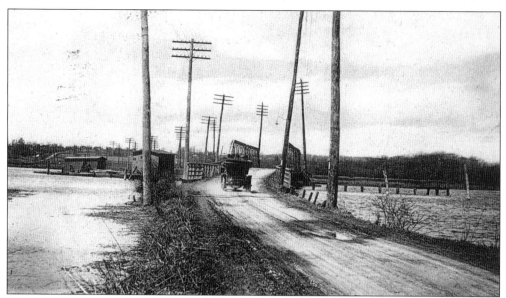

THE OVERPECK BRIDGE. In 1828, the Hackensack-Fort Lee Turnpike was completed, and this drawbridge crossed the Overpeck Creek. There were gates across the pike on both sides of what is now Grand Avenue, and tolls were taken on the corner porch of a nearby hotel. Before and after the railroad came in 1859, stagecoaches ran north, south, east, and west. Fort Lee Turnpike was renamed Central Avenue and, in 1945, was renamed Fort Lee Road. In the late 1800s, the government dredged the creek so that barges could deliver coal to Englewood.

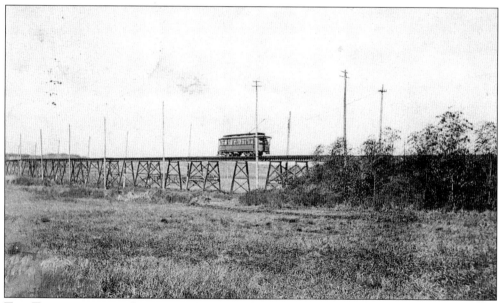

THE TROLLEY ON THE OVERPECK TRESTLE. The first trolleys came to Leonia in 1896. They originated at the ferry dock in Edgewater. One went to Englewood via Broad Avenue. The Hackensack Line, seen here, went down Hillside Avenue and passed over the Overpeck Creek on this trestle. Trestle ruins can still be seen in the creek. The trolley fare was 5¢. The trolleys ceased operating in Leonia in 1938, and the tracks were removed. Hillside Avenue (Riley's Lane) was one of the first developed streets in Leonia.

THE VILLAGE, 1895. Leonia's village was located on Fort Lee Road by the railroad tracks. On the south side of the street (seen here) is the town hall, which housed the fire department, police department, and the municipal offices. These buildings were constructed in 1895. Also on this side of the street were Mott Allaire's livery stable, Minerly's blacksmith shop, and a general store that sold Stickel's ice cream. The original borough hall burned down in the 1990s.

THE VILLAGE, FROM GRAND AVENUE, 1895. On the north side of Fort Lee Road were Ferdon's coal store, Willie Moore's hardware store, the Leonia Lyceum, a general store and post office, the train depot, and a Chinese laundry. The train brought the mail every day at 5 p.m. Since there was no borough mail service, residents gathered at the general store to get their mail.

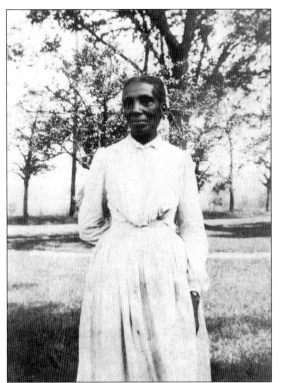

MRS. JACKSON, DOMESTIC HELPER, C. 1900. Until the 1920s, wealthier families in Leonia had live-in domestic help for cooking, sewing, grooming horses, gardening, cleaning, and minding children. With the arrival of the automobile, the invention of more labor-saving devices, and the onset of the Great Depression, fewer families relied on household help for day-to-day chores. Shown is Mrs. Jackson, a domestic helper at the Moore house.

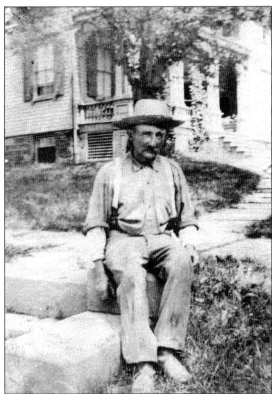

BILLY COWLS, FARMHAND. Few farms remained in Leonia after the late 1800s. Shown is Billy Cowles, a farmhand at the Moore estate.

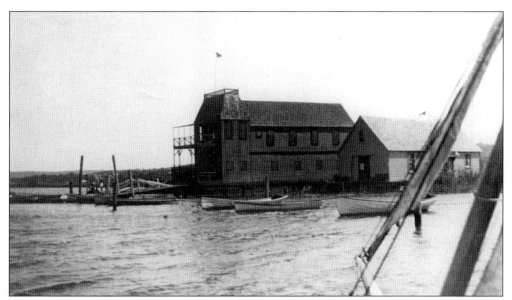

SAILING ON THE OVERPECK, C. 1900. Leonia's western border is Overpeck Creek, which, in 1900, was a lush 1,200-acre natural habitat teeming with wildlife. Since the creek drains into the Hackensack River, its name probably comes from the Dutch word *overbeck,* which means "upper creek." Pictured here are two boat docks in 1900, when the creek was frequently used for sailing, rowing, and canoeing. Leonians sailed on the open water in the summer. In the winter, ice sailing and ice-skating were popular pastimes. In the 1920s, the Regional Planning Association of the New York Metropolitan Area proclaimed the creek and its banks to be "one of the finest opportunities for preserving an open space of exceptional beauty in the metropolitan area, a Central Park for New Jersey."

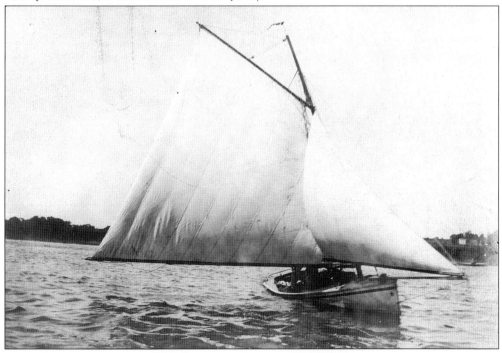

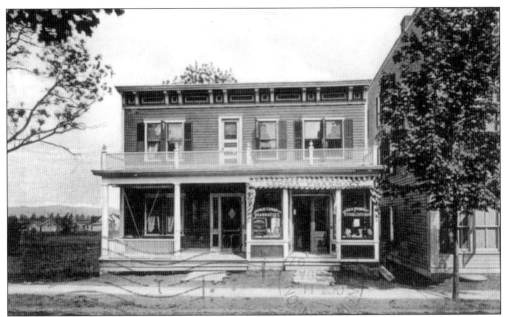

THE LEONIA PHARMACY. Leonia's first pharmacy was established by John B. Cowan in 1899 just north of the village at 388 Grand Avenue. Medicine bottles made of colored glass, with "Leonia, NJ" inscribed on them, were used to dispense drugs. Other businesses in the immediate vicinity included the one-armed butcher, William Hartmann.

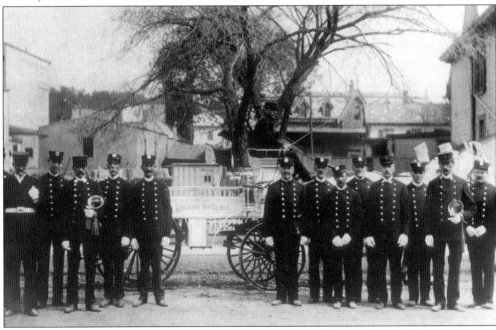

THE LEONIA VOLUNTEER FIRE DEPARTMENT. The Leonia Volunteer Fire Department was formed in 1898 with a hand-drawn hose cart and a hook and ladder with drag ropes. The first firehouse was located on Fort Lee Road west of Grand Avenue. A second firehouse was built on Irving Place to deal with fires on the east hill. Shown here are early members of the Leonia Volunteer Fire Department at a convention in Englewood in 1903.

Two
Leonia Landscapes

Leonia's proximity to New York City and transportation advances in the early 1900s—such as the ferry, the trolley, and the subway—made Leonia an attractive community for commuters. In the years before and after Leonia became a borough, local land speculation began in earnest. The first subdivision was Leonia Park in 1885. This was followed by Villa Sites of Leonia, on Park Avenue. It was Leonia's third planned development, Leonia Heights, that defined the future of Leonia as a community. In 1895, Columbia University moved to 116th Street in Manhattan, leaving many professors looking for places to live. A Madison Avenue advertising genius named Artemus Ward conducted an intense 15-year advertising campaign to lure academics to Leonia. With posters plastered all over the New York City subways proclaiming Leonia the "Athens of New Jersey," the community drew a large number of academics and other professionals. By 1920, the Leonia Heights development was complete. Several real-estate offices opened up in Leonia, and the remaining land was rapidly developed. In the decade that followed, five Nobel Prize winners called Leonia home.

During this intense period of development, two new town centers developed. In 1895, trolley tracks were laid on Broad Avenue, and the first trolleys came a year later. The trolleys intersected at the junction of Broad and Hillside Avenues. The Junction, as it was called, became the second downtown district in Leonia, with an A & P market, a luncheonette, a bootery, and several real-estate offices. In the 1920s, a third downtown district developed at the corner of Fort Lee Road and Broad Avenue, with Leonia's first bank, a food market, a drugstore, and more real-estate offices. Prudent zoning laws implemented in 1921, under Mayor John Pollock, banned stores along most of the two main thoroughfares, which was a key decision in determining the residential character of the town.

The photographs in this chapter show how Leonia evolved from an area of open spaces to a densely populated, yet charming, tree-lined suburb of New York City.

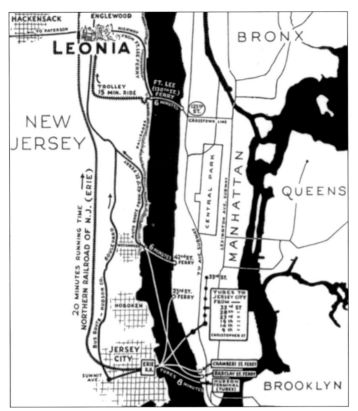

ALL ROADS LEAD TO LEONIA. Leonia appears to be the center of the New York metropolitan area, according to this c. 1920 map from a real-estate brochure. The convenience of public transportation to the city had great appeal to academics, artists, businessmen, and skilled tradesmen. This resulted in the rapid growth of the community.

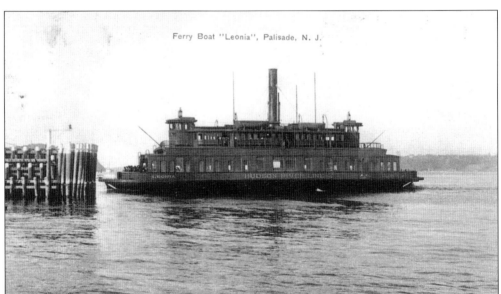

THE FERRYBOAT LEONIA. The 125th Street ferry started running between New York and Edgewater in 1889. Many ferryboats were named after Bergen County communities, such as the ferry *Leonia*, which was commissioned in 1906. Trolleys came in 1896. With the West Side Subway completed in 1898 and the ferry and trolley lines meeting at Edgewater, conditions were perfect for commuters.

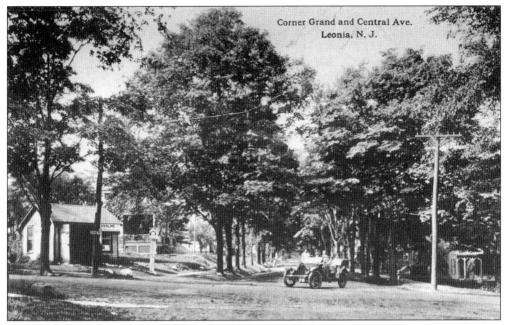

GRAND AVENUE, SOUTH FROM FORT LEE ROAD, C. 1910. This photograph is among the first to show an automobile in Leonia. On the left is a gasoline station. Shade trees have been planted along the road, perhaps by Mayor Cornelius Christie, who personally planted many along Grand Avenue. The local hotel, which went by various names, was also located in the foreground. About a mile south is the Civil War drill hall.

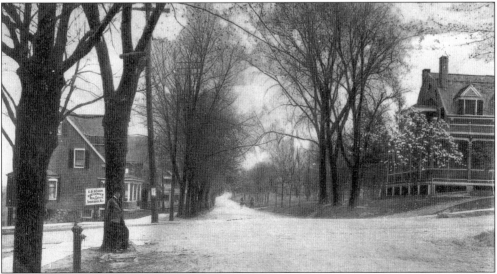

GRAND AVENUE, NORTH FROM FORT LEE ROAD, C. 1910. A former Native American trail and main thoroughfare through Bergen County, Grand Avenue was called the Kings Highway and the English Neighborhood Road. On the northeast corner was David Christie's homestead, which was razed by the WPA in 1935 to provide work for the unemployed. The sign on the left advertises C.D. Schor's auctioneer business.

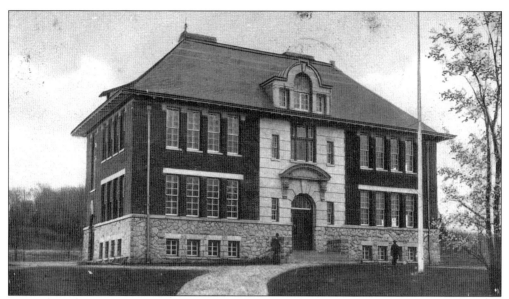

THE LEONIA ELEMENTARY SCHOOL, 1905. Leonia resident Frederick West of the architectural firm McKim, Mead, and White designed this Beaux Arts–style school on Broad and Crescent Avenues. It was constructed in 1904 at a cost of $16,710. It opened in 1905 with 100 students and 3 teachers. At the time, this undeveloped area was considered ideal for learning. The principal was L.L. Rosenkrans. Teachers were Dorothy Rosenkrans and Rebecca Gismond.

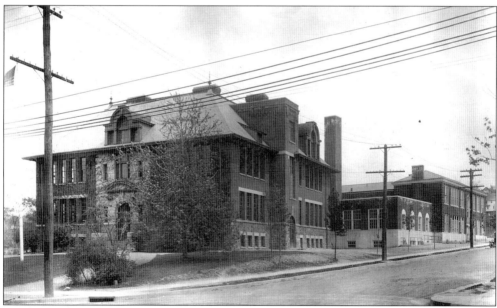

THE ELEMENTARY SCHOOL, 1924. As enrollment grew, the school was enlarged and more land was purchased throughout the early 20th century. In 1923, voters approved $200,000 for a third addition along Highland Street, which included a new auditorium, science classrooms, and general classrooms. Later, in the 1950s, a major two-story extension reaching Fort Lee Road was constructed. The original wing burned in 1974 and was later demolished. A new addition was built on this site in 1997.

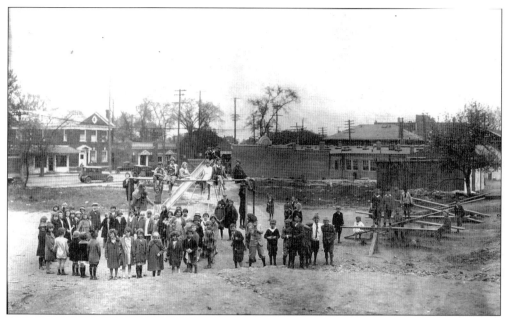

CHILDREN ON A SCHOOL PLAY LOT, 1924. This dirt play lot, with swings, monkey bars, and seesaws, was typical of the times. Many grammar school alumni from the early part of the century recall the open fields surrounding the school. By 1924, the fields were disappearing, and Broad Avenue businesses, including the Telephone Exchange Building, can be seen in the background.

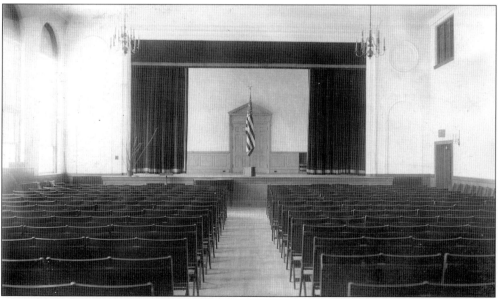

THE ELEMENTARY SCHOOL AUDITORIUM, 1924. This auditorium was rented to many organizations in town for meetings, annual art exhibits, and for theatrical productions. In 1936, Leonia artist Howard McCormick painted historic murals on either side of the stage as part of a WPA arts project. The chandeliers have been removed, as the room now serves a dual purpose—as gymnasium and auditorium.

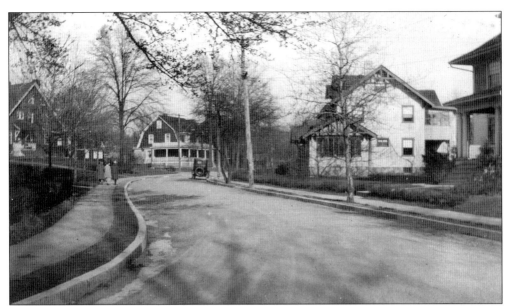

CRESCENT AVENUE, 1922. In 1885, Crescent Avenue was created as part of Leonia's first subdivision, Leonia Park. Other streets in the subdivision were Prospect, Maple, High, and Terrace. Leonia Park was designed with winding narrow streets to resemble charming country lanes. Sidewalks and curbs were not added until the early 1920s. Leonia Park took several decades to develop. Homes ranged from working-class cottages to ornamental Victorian homes.

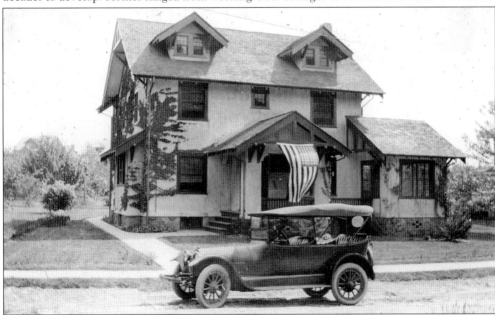

THE HOUSE AT 196 CRESCENT AVENUE, 1918. The Chace family home, built by W.P. Richards, is shown with a flag waving in front, perhaps to show support for the American effort in World War I. Richards had a home on Prospect Street. He built hundreds of homes in town, most with a stucco finish, a large front porch, and dormers. Six generations of the Chace family have lived in this home, including Secor Chace, who served on the fire and police departments for a number of years.

HIGH STREET NEIGHBORHOOD CHILDREN, 1917. Before the creation of public parks, most children in Leonia gathered for play at a favorite sandbox, field, or empty lot, of which there were plenty in 1917. These children are playing in a sandbox in the side yard of 115 High Street. Instead of play clothes, they are all dressed up in their finest shirts, ties, and frocks. Perhaps they were chased out of the house after eating Thanksgiving turkey.

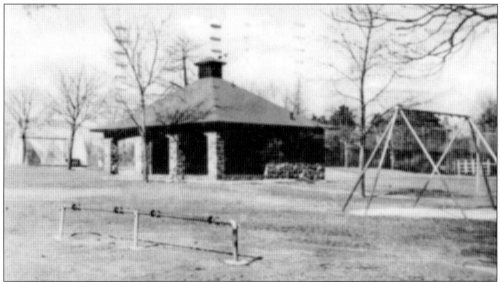

WOOD PARK. Deeded by the Wood family for park purposes in 1923, the land was used for recreational activities. The recreation commission was formed in 1946. After that, it was used year-round. Sylvan Park was added in 1950, followed by Fireman's Memorial Park and the municipal swimming pool in 1962. In 2000, Leonia had seven public parks, with Wood Park being the most popular.

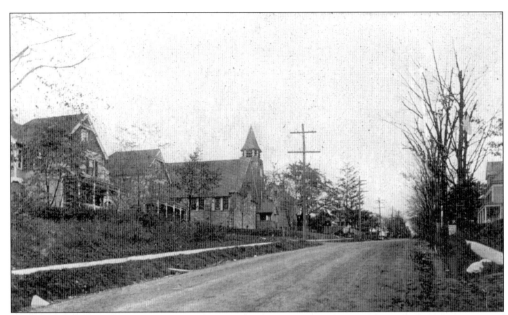

FORT LEE ROAD, FROM ROMAINE PLACE (NORTH SIDE), C. 1915. Before zoning laws changed in the late 1920s, permitting apartment buildings to be built on parts of Fort Lee Road, a number of farmhouses lined the unpaved road. In the background is the Presbyterian church.

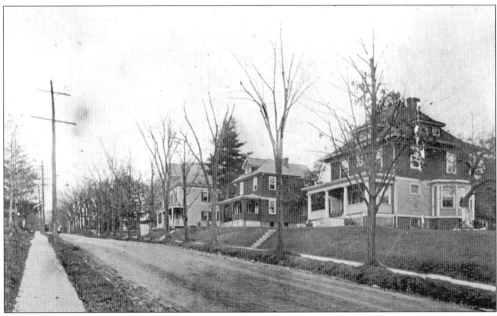

FORT LEE ROAD, FROM ROMAINE PLACE (SOUTH SIDE). Fort Lee Road, formerly called Central Avenue, was supposed to be the route the trolley would take to Hackensack. Arthur Gladwin and Nicholas Romaine, both of whom were prominent landholders along Fort Lee Road, expressed opposition, claiming that the noise might upset their farm animals. Instead, the trolleys detoured north on Broad Avenue.

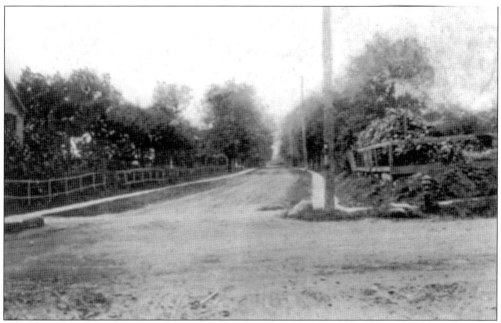

LEONIA AVENUE, LOOKING NORTH, C. 1899. This scene, where Leonia Avenue intersects Fort Lee Road, depicts the rural nature of Leonia at the turn of the century. Fire hydrants and water pipes were installed in 1897. Utility poles were installed and sidewalks were paved (even though streets were not). The Leonia Presbyterian Church was built on the northwest corner in 1901, on land donated by two sisters. Leonia Avenue south was an apple orchard at the time.

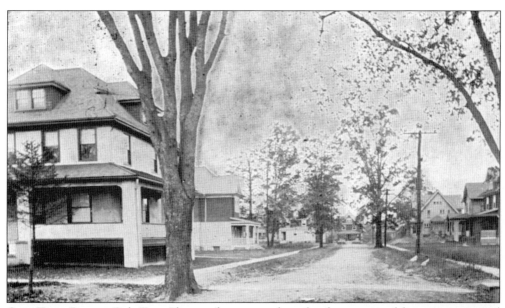

OAK TREE PLACE. Oak Tree Place, a former peach orchard, was one of four streets created when the Gladwin Farm was sold. In 1780, the Marquis de Lafayette camped in the area with approximately 2,000 troops that served as an advanced guard for Washington's troops.

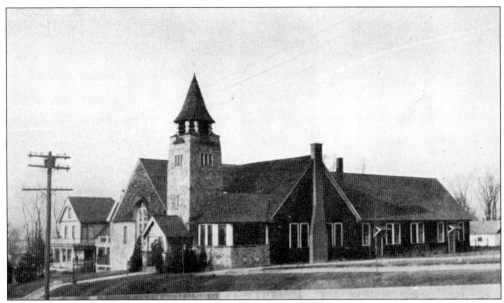

THE LEONIA PRESBYTERIAN CHURCH. This church was organized in 1899 with 58 members. The first pastor was Rev. James Wyckoff. This building was constructed in 1901. It was enlarged, to include a pipe organ, in 1907. In 1918, a social hall and education building were added to accommodate the growing membership. By 1949, the church had 877 members, three services on Sunday, and committees that met every day and night of the week.

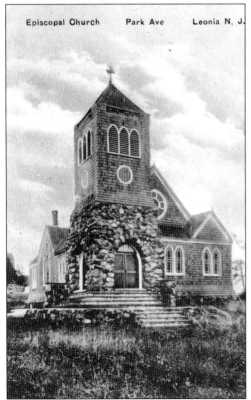

ALL SAINTS EPISCOPAL CHURCH. The first services were held in January 1894 in the Leonia Lyceum. The congregation acquired land on Park Avenue at Orchard Place in 1897, and the church was completed in 1898. The All Saints parish house served as a community center, hosting the Red Cross, the American Legion, the Royal Arcanum, and the Trinity Lutheran Church. For almost half a century, it was home to the Players Guild of Leonia. The church had 500 members in 1944.

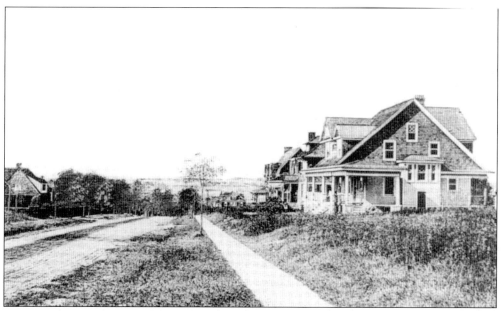

PARK AVENUE, BETWEEN BROAD AND GRAND, 1906. In 1888, Cornelius Christie, who became Leonia's first mayor, purchased the strip of farmland now known as Park Avenue. He and his brother-in-law Edward Stagg, the first president of the board of education, built homes on the land and called the planned community Villa Sites of Leonia. The houses sold from $2,700 to $3,800.

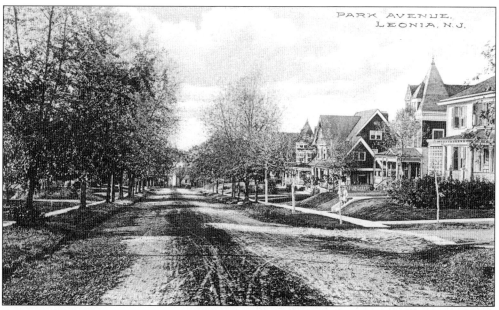

PARK AVENUE, WEST OF ORCHARD STREET. Villa Sites had numerous rules. Houses had to be two and a half stories, could not have a flat roof, and could only have one barn. Livery stables, liquor sales, and manufacturing were forbidden. All the lots were sold by 1900. In 1910, seven of the 16 cars in Leonia were housed on Park Avenue.

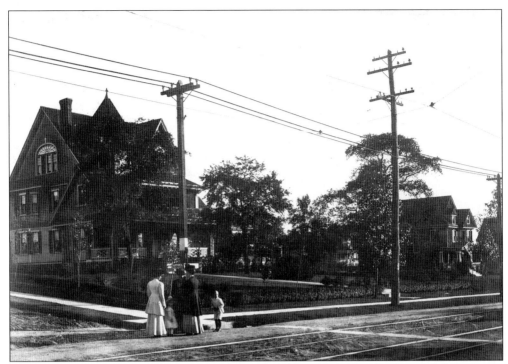

HOME HUNTING IN LEONIA. These women and children might be checking out Leonia as a future home. Many longtime Leonians recall taking a weekend trip to the country, by ferry and trolley, and touring Leonia. After the tour, most were taken to one of the many real-estate offices on Broad Avenue to discuss purchasing a home.

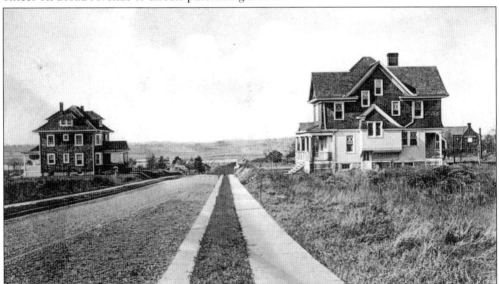

THE LOOMIS HOUSE, HIGHWOOD AVENUE. Shown in the foreground is the Charles Battell Loomis house, overlooking the Overpeck Creek. Noted artist and children's author of the *Tuck Me In Stories*, Enos Comstock designed his home and studio farther down at 176 Highwood Avenue. Within a couple of years, the entire street would be developed. Homes in Leonia were known by the owner's name, not the address.

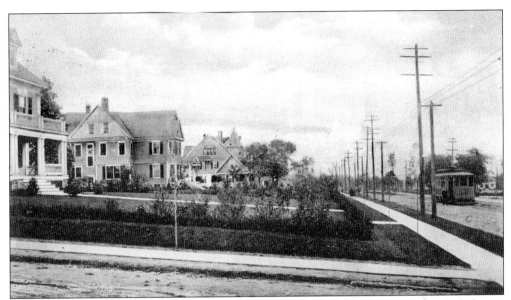

BROAD AVENUE MANSIONS. Broad Avenue dates from 1870. In the late 1800s, several elegant homes were built on large lots on Broad Avenue, south of Fort Lee Road. Owners of these homes, considered the finest in Leonia at the time, included developer R.D. Paulin and H.S. Ferdon, owner of the coal depot. The house in the foreground, on the corner of Park and Broad, was demolished.

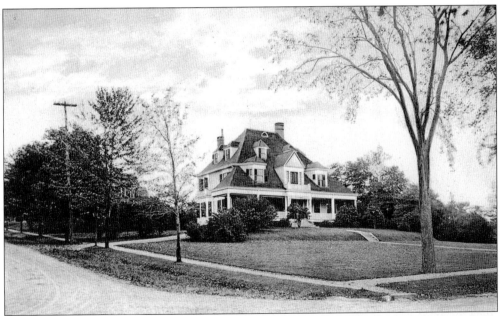

THE BOGERT HOUSE. This stately home, designed by Stanford White, was on the northeast corner of Broad Avenue and Christie Street. After zoning laws were changed in the late 1920s, it was torn down to allow apartments on that section of Broad Avenue. Development had stalled on Broad Avenue because many prospective homeowners were offended by the noise and dust generated by trolleys. The first apartment building in Leonia was built in 1927 on the southeast corner of Christie Street and Broad Avenue.

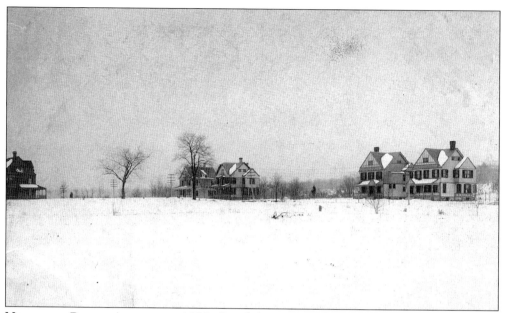

NORTHERN BROAD AVENUE, C. 1892. Broad Avenue was little more than a dirt path lined with swamps before the arrival of the trolley in 1895. This winter scene shows the scarcity of houses in the northern portion of Leonia. The five homes shown here still stand. The home on the left, on the southwest corner of Christie Heights and Broad Avenue, later became a boardinghouse for artists and teachers.

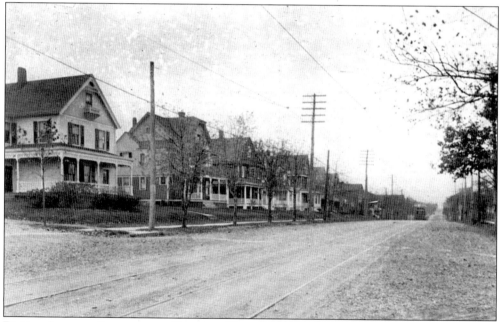

BROAD AVENUE, SOUTH FROM CHRISTIE HEIGHTS STREET, C. 1900. These were among the earliest homes on the north end of town. They were built on a cornfield, and their backyards bordered the Gallagher farm. When built, these homes had running water but existed without sewage systems until 1905. Oil lamps were used for lighting, and coal was used for heat.

THE SHEDD HOME, 499 BROAD AVENUE. The Shedd home was built c. 1900 at the north end of town and is the only one still owned by the same family. Cornelia Shedd was the librarian at the public library for 25 years. The Shedds were one of the few families in early Leonia that admitted to being Democrats. Behind the house was the Englewood Golf Course. Created in 1889, it was one of the first golf courses built in the United States. The Shedd's neighbor was Harry Stark, a Scotsman who designed and managed the golf course.

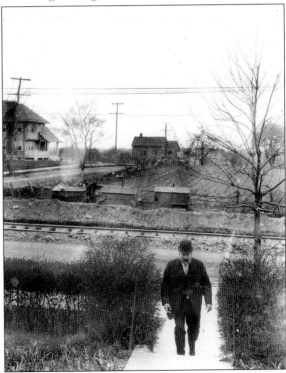

TEMBUSCH FARM, BROAD AVENUE, c. 1908. Taken from the front stoop of the Shedd home, this photograph shows the Tembusch Farm with animal sheds in the foreground. Four years later, in 1912, the Leonia High School was built on that property. Most of the homes built on Christie Heights Street had barns in back that housed the horses used for transportation. With the arrival of the automobile, many of those barns were converted into artist's studios.

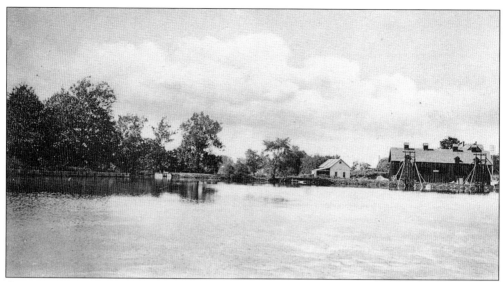

CRYSTAL LAKE. Crystal Lake, located on Englewood's southern border, was a popular ice-skating pond for Leonians in the winter. It had a skate house, and festive lights were strung around the lake for evening skating. It was a favorite destination for families and groups of young people. In the "old days," a gristmill and a dyeing establishment were nearby.

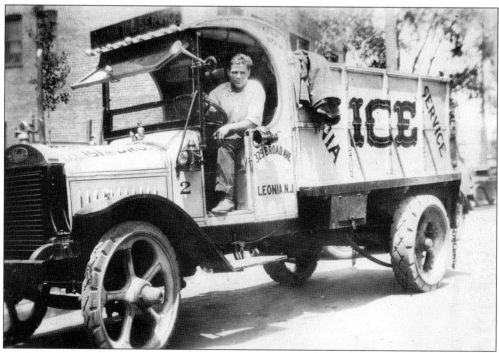

AN ICE TRUCK. For most, food shopping was an everyday occurrence in the days before refrigeration. Once iceboxes became available, everyone looked forward to the visit of the ice man. Most likely, this ice was obtained from the ice-manufacturing plant in Palisades Park.

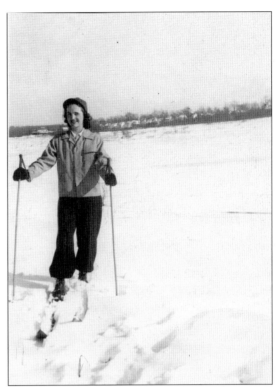

THE GOLF COURSE. Skiing and bobsledding were favorite winter pastimes on the golf course at the north end of town. The 18-hole course, one of the oldest in the country, was the first to permit Sunday golfing. The Men's U.S. Open was played there in 1909. In the summer, young Leonians made money caddying for visiting celebrities such as Ed Sullivan, Mickey Mantle, Perry Como, and Tony Bennett. Since the club was public, Jews, Catholics, and African Americans such as Jackie Robinson and Althea Gibson frequented it. To the right is Cay Shedd. Below is the golf course as seen from her backyard c. 1943.

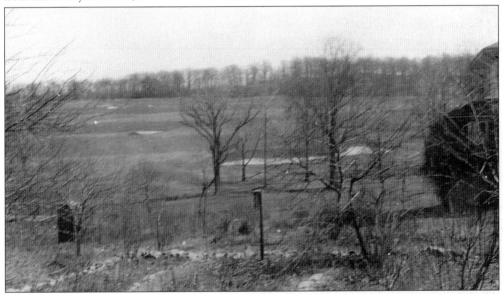

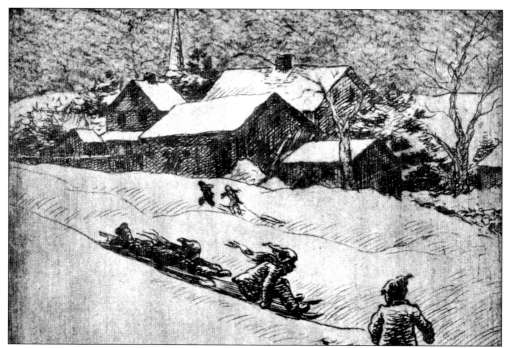

DOWN THE HILL. This sketch by noted Leonia artist Grant Reynard shows a favorite winter pastime—sledding down the golf course hill.

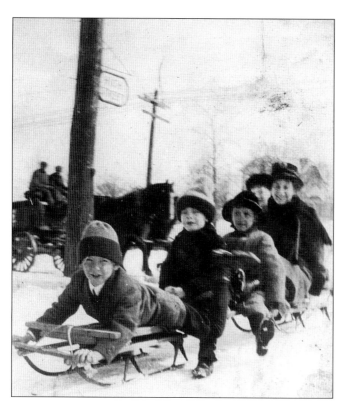

SLEDDING ON HIGH STREET, 1914. Leonia's hills made it ideal for sledding. The favorite sledding spot in town was the golf course, but after a big snow, several streets would be closed to traffic so children could sled safely. Shown are members of the Chace family. In the background is a horse pulling a wagon. Many recall sledding down Fort Lee Road in the butcher's sleigh.

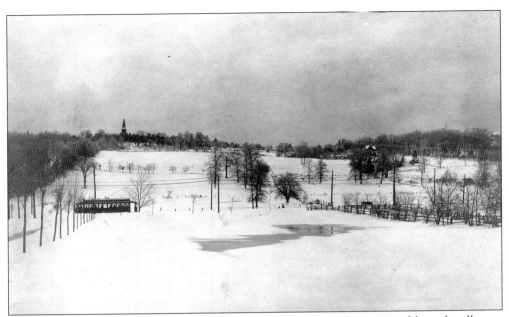

A TROLLEY ON BROAD AVENUE, C. 1900. This winter scene shows a northbound trolley on Broad Avenue. At the top of the hill is Madonna Church, in Fort Lee. The wooded, undeveloped area on the left is now Holy Spirit Lutheran Church and the Glenwood Retirement Housing. Directly behind the trolley is where the American Legion hall was built. An undeveloped Glenwood Avenue can be seen in the background. Leonians wrote about putting the driver and passengers up for the night when a trolley got stuck in the snow.

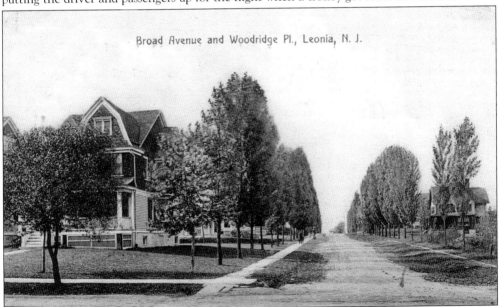

WOODRIDGE PLACE, LOOKING WEST FROM BROAD AVENUE, C. 1905. The two homes in the foreground still stand. Today, however, a modern mini-mall—with a barbershop, a hair salon, a stationery store, and a television-repair store—now occupies the front lawns. These shops were installed before the 1921 zoning laws went into effect, which did not allow mixed usage of property. The Methodist church was later built on the land across the street.

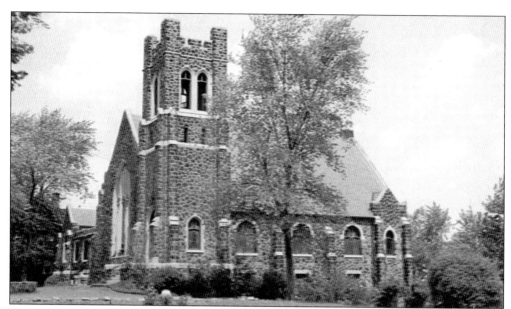

THE METHODIST CHURCH. In 1915, the Methodists dedicated their impressive Gothic-style church on the corner of Broad Avenue and Woodridge Place. In 1970, the sanctuary became home to the Leonia Chamber Musicians, a group of professional musicians who have performed classical music concerts there for more than 30 years. The Methodist church was also home to the first Korean congregation in New Jersey. The 600-member congregation used the church for afternoon services for 30 years, until 2001.

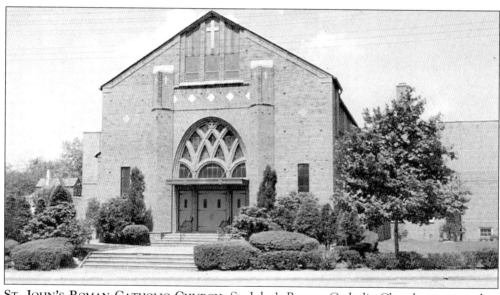

ST. JOHN'S ROMAN CATHOLIC CHURCH. St. John's Roman Catholic Church was started in 1911 in a vacant upholstery shop on Grand Avenue. Carmelite priests from Englewood took turns taking confession, making home visits, and instructing the children. In 1913, the first permanent priest, Fr. Stephen McDonald, was appointed. He purchased the original wooden Methodist church building. After years of fundraising, this new church was dedicated in January 1940. The school was built in 1941.

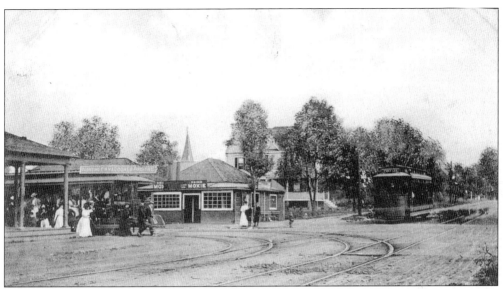

THE JUNCTION AT HILLSIDE AND BROAD. The arrival of the trolleys led to the development of a new town center, which was known as the Junction. Several amenities sprang up at the Junction, including a general store and a luncheonette. The spire in the background belongs to the first Methodist Episcopal church. The open-air trolley is returning from Englewood. Note the billboard advertising Moxie drinks and Waggoner's Plumbing and Heating business on the corner.

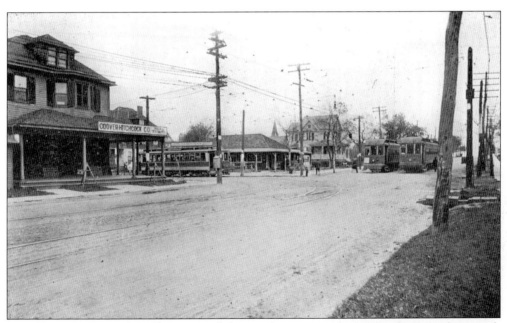

THE JUNCTION, C. 1914. This postcard depicts the same intersection a few years later, with three trolleys arriving simultaneously. The white house in the center still stands. The small building to the south of the house was the first library in town, which was privately financed. On the left is the Coover Hitchcock real-estate office, which promoted development of the north end of town. On the northeast corner was Lehman's General Store, which opened in 1904.

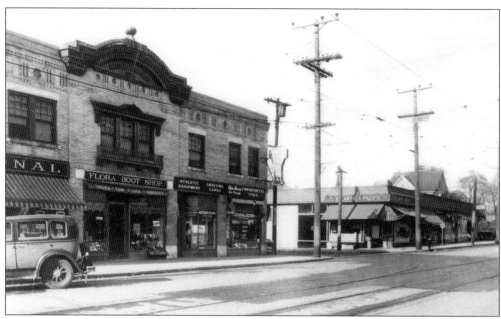

THE LEONIA JUNCTION. The look of the Junction changed after the two-story brick Coover Building was built on the southwest corner in 1917. The northwest corner was occupied by a National store, which later became an A & P, as shown here. Many of the new residents in this part of town were skilled laborers who purchased the smaller farm-style homes and found gainful employment building the rest of the town.

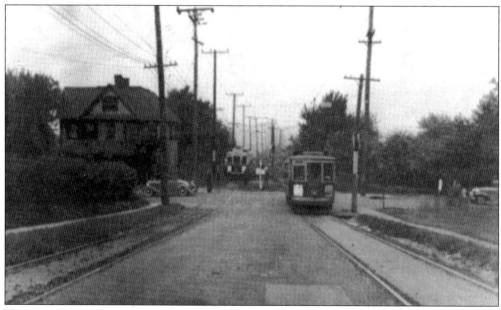

TROLLEYS AT HILLSIDE AND GRAND. This photograph shows two Hudson River Line trolleys, each approaching the intersection of Hillside and Grand Avenues. One is headed west to Teaneck. The other is headed east to the Edgewater ferry terminus. A trolley trestle was built over the railroad tracks and over the creek.

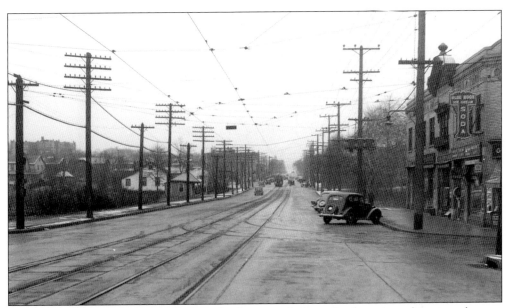

LEONIA JUNCTION, LOOKING SOUTH. Looking south from the Junction, this view shows a paved Broad Avenue in the 1930s, before the Manor Apartments were built in 1944. The white building on left is the American Legion hall. Mayor Dudley E. Allen had the utility poles in the business district removed in the 1950s as part of a downtown beautification effort. The Coover Building in the foreground was built in 1917. In 1944, ACME Market was built.

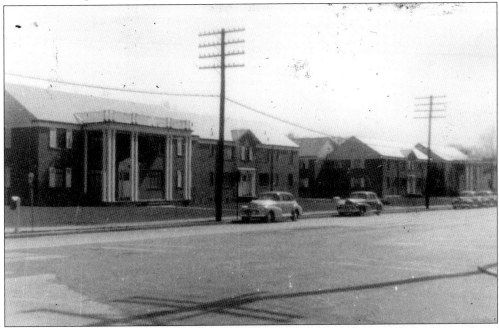

THE MANOR APARTMENTS, 1946. This photograph shows the Manor Apartments on Broad Avenue shortly after they were built. There was a great need for affordable housing for veterans after the war. Italian immigrant Hercule Tamborelli built three two-story buildings, which held a total of 52 units. The buildings were converted to condominiums in the 1990s, as were many other Leonia apartment buildings.

OLD ORCHARD SCHOOL, 223 LEONIA AVENUE. From 1912 to 1925, Anna Noyes operated an exclusive day school for city children out of her Leonia home, which overlooked the Hillside Avenue brook. Many students boarded in her home. She compiled a book of stories told by her mother, the well-known storyteller Grandma Gausmann, a descendent of the Moore family. The book was entitled *Three Petticoats*.

BENNETT'S BOARDINGHOUSE, 490 BROAD AVENUE. Located on the southwest corner of Broad Avenue and Christie Heights Street, this early Leonia home was owned by the Beeching family. Later, after extensive remodeling, the house was purchased by Clara Bennett (shown in front of the house), a widow who rented rooms to artists and teachers in the 1920s.

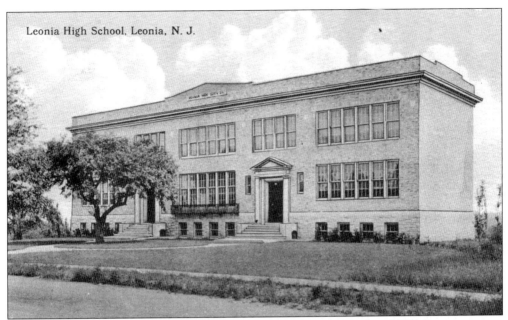

LEONIA HIGH SCHOOL. Leonia High School opened in September 1913. Its convenient location along the trolley line attracted students from seven surrounding towns. It advertised itself as the most modern secondary school in the state and boasted 18 classroom and recitation rooms, an auditorium that seated 500, manual training and domestic science rooms, separate gymnasiums for boys and girls, drinking fountains, showers and locker rooms, and foot warmers in the classrooms. The first commencement was held in 1915. This school became a middle school in 1977, after a new high school was built in the Overpeck meadows. An addition facing Broad Avenue was built in 1917. Another addition, on the west side, was built in 1937.

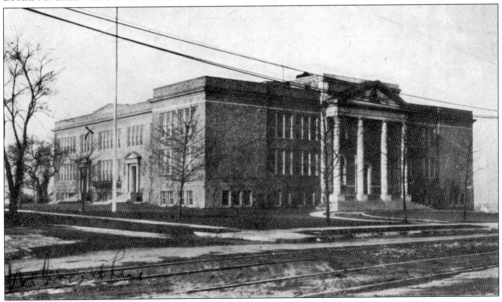

A LEONIA HEIGHTS LAND COMPANY CALENDAR, 1913. The Leonia Heights Land Company used every promotional device imaginable to market Leonia as the "Athens of New Jersey." Professional artists were hired to design calendars, postcards, brochures, booklets, and subway posters that portrayed Leonia as a charming community with well-kept, tree-lined streets, picturesque homes, good schools, and clean air. Shown below is a map of the Leonia Heights section of town and the Leonia Heights real-estate office on Park and Broad Avenues.

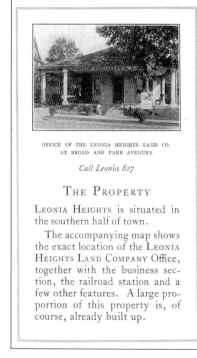

OFFICE OF THE LEONIA HEIGHTS LAND CO.
AT BROAD AND PARK AVENUES

Call Leonia 827

THE PROPERTY

LEONIA HEIGHTS is situated in the southern half of town.

The accompanying map shows the exact location of the LEONIA HEIGHTS LAND COMPANY Office, together with the business section, the railroad station and a few other features. A large proportion of this property is, of course, already built up.

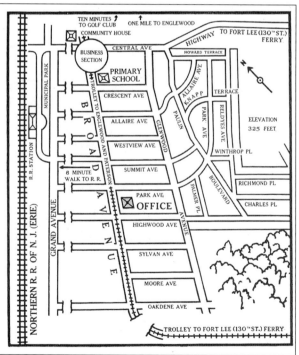

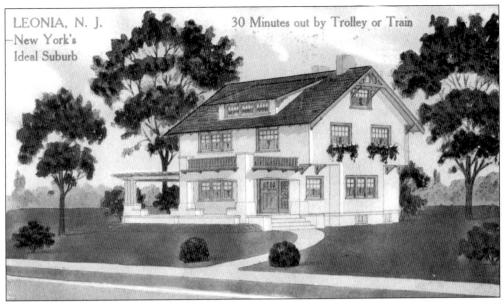

LEONIA HEIGHTS PROMOTIONAL POSTCARDS. The area of town known as Leonia Heights ran from Broad Avenue east to Route 46 and from Fort Lee Road south to Oakdene. The Leonia Heights Land Company designed over a dozen color postcards depicting sample homes that ranged from $5,000 to $15,000. A favorite builder was W.P. Richards, who lived on Crescent Avenue. Homes offered amenities such as tiled bathrooms, maid's rooms, billiard or music rooms, and butler's pantries.

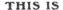

LEONIA HEIGHTS PROMOTIONAL POSTCARDS. On the back of each postcard, specific features of each home were listed. These homes were noted for superb craftsmanship, inside and out. Skilled craftsmen were hired to construct the homes, which were also considered works of art. Stained-glass windows, parquet floors, inglenooks, pergolas, hand-carved cabinets, and ornate staircases were common.

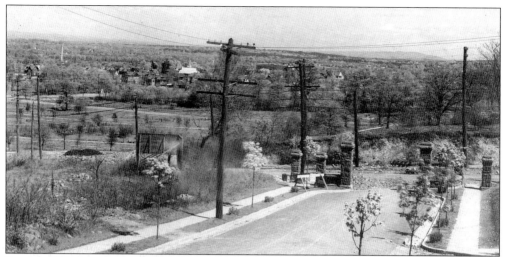

LOOKING NORTH FROM PAULIN BOULEVARD. These red sandstone pillars at the intersection of Paulin Boulevard and Fort Lee Road marked the gateway to the Leonia Heights development. Pictured are the undeveloped Glenwood and Broad Avenues. Albert J. Stone, the general superintendent of the Erie Railroad Company, built one of the largest homes in Leonia Heights, just south of the pillars. He used his influence to have a new commuter railroad station built at Station Parkway.

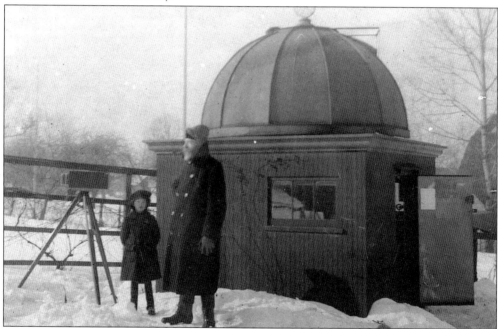

THE LEONIA OBSERVATORY. Perhaps one of the most fascinating Leonians was Dr. J. Ernest Yalden, an inventor who had a passion for astronomy, sundials, sailing, architecture, mineralogy, and conducting orchestras. He also owned the first car in Leonia. He built this observatory in the backyard of his Woodridge Place home. All Leonians were welcome to stargaze there. He was a founder of the Whetstone Club, an organization of Leonia men who met regularly to discuss new ideas. He willed his home to be used as a community museum, but Leonia zoning laws did not permit it.

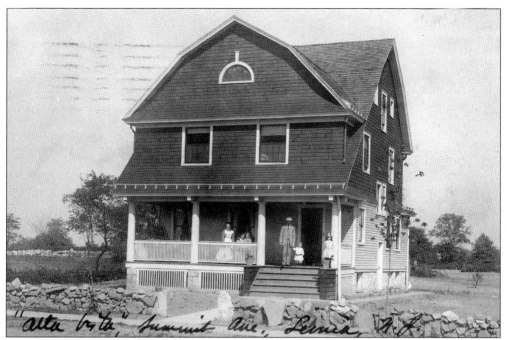

THE HOUSE AT 341 SUMMIT AVENUE. Stone walls were common when these homes were first built. When it came time to pave Grand Avenue, many of these walls came down. The stones were crushed and used in paving roads such as Grand Avenue.

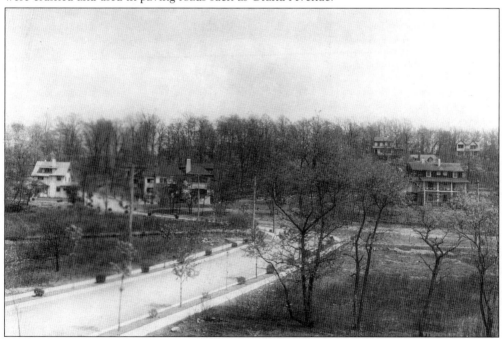

LEONIA HEIGHTS, FROM ALLAIRE AVENUE, C. 1905. Sidewalks and curbs were laid, and shade trees were planted before the homes were built. Leonians received financial assistance in the building of their homes from the Leonia Building and Loan Association, a profit-sharing institution formed by Mayor Wilbur Osler in 1913.

given to possible new comers 1915

THE college man's wife likes Leonia because she sees her children thrive here. They form pleasant companionships, they develop their bodies with healthful outdoor exercise; they play not in streets but in the grounds surrounding their homes and schools, they are free from the dangers of the city.

Leonia has well been called the "scenic suburb" as it commands a sweeping view of rivers, fields and mountains. Its picturesqueness has led many artists and art lovers to establish homes here.

A college professor now building a home in Leonia writes "I hope they are hurrying my house up so that I can get in Leonia and live a life a civilized man should live"

We want more college men in Leonia. It is a place which merits your investigation and whether you locate here or not it will be a pleasure for this office to give you the benefit of its experience and information.

BOWLES & COMPANY
Broad and Central Aves. Leonia, N. J.
"Leonia's Leading Real Estate Office"

Leonia

The Logical

Place for the

College Man *or woman* to live

LEONIA: THE IDEAL PLACE FOR THE COLLEGE MAN, C. 1915. Pamphlets such as these were widely distributed by real-estate agents Moore, Paulin, Boles, Coover, Van Orden, and Day. These pamphlets emphasized good schools, mentally stimulating clubs, and cultured company.

VERY year more university men are coming to Leonia to live. Columbia, the City College, New York University, the Baron De Hirsch Trade School, the Ethical Culture School, Union Seminary, all have contributed to Leonia's population.

One University man has brought another

There are several reasons why Leonia is the logical suburban place for the college man to make his home. First of all is its convenience. The high speed trolley connecting with the West 130th Street ferry brings Leonia within twenty five minutes of Harlem. This service continues until two in the morning, a car every fifteen or twenty minutes. Here is a place where truly "your watch is your time table" with trains not once an hour, but three and four times an hour, during the day and evening. The college man must keep irregular hours, often he must work at night. He does not want to go to a suburb served only by a railway which runs its evening trains once every two hours with the last train around midnight. The City College and the Columbia man is within fifteen minutes walk of the ferry if he lives in Leonia, and if he is attending a college dinner he can stay as late as the latest, knowing that he will get boats up to two o'clock.

HE college man likes, too, the convenience to New York for his family. His wife and children can make the round trip by trolley and ferry for twenty cents, while on trains the round trip is generally sixty or seventy cents. But Leonia also has good train service which is used by commuters to down town points.

After a hard day's work the college man likes the quiet of Leonia. Here he is away from the noise, crowds and demands of his students. Yet he and his family find a congenial social atmosphere. There are athletic, card and literary clubs. There is the Men's Neighborhood Club which meets once a month and listens to some good speaker. There are numerous musicales, plays and lectures.

The university man wants good schools for his children. He finds these in Leonia. Not long ago Leonia built a new high school which is attended by pupils from half a dozen surrounding boroughs. If you talk to Mr. Garver, the young and energetic supervising principal of our schools, he will tell you that he is trying to make the Leonia schools the best in this country. Several of the college men living in Leonia are members of the Board of Education.

This marketing strategy was successful, for in 1925, it was reported in the county newspaper that 80 percent of adults in Leonia had college degrees or professional training.

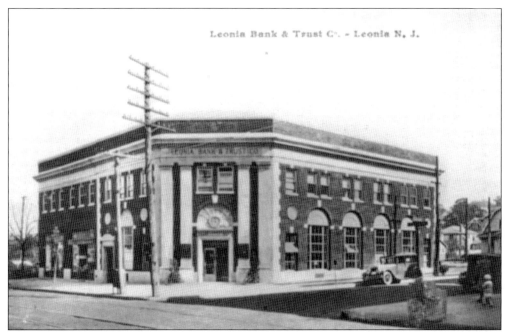

THE FIRST NATIONAL BANK. Leonia's first bank was formed in 1921. It became the Leonia Bank and Trust in 1926, the year this neoclassical building was completed on the corner of Broad and Elm. At one time, the Hudson River trolley passed its front door, and the Fort Lee trolley crossed the rear of the building. The bank helped finance the construction of homes and businesses in town.

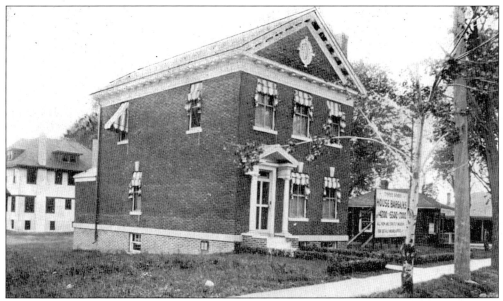

THE TELEPHONE EXCHANGE BUILDING, 1911. The first telephones in Leonia were purchased by businesses in the late 1890s. Individuals slowly caught on to the new concept after the turn of the century. In 1911, the Telephone Exchange Building was built. At its peak, more than 40 telephone operators staffed switchboards. The small building to the north was a real-estate office and then the library. In 1953, the Telephone Exchange Building became the borough hall.

HOLY TRINITY LUTHERAN CHURCH, BROAD AVENUE. The Leonia Lutheran Church was formed in 1926. Two years later, the struggling congregation split over doctrine. Members favoring the United Lutheran Mission formed Holy Trinity Church. In 1942, they built this church on the corner of Broad Avenue and High Street, with the help of a financial gift from singer Bing Crosby. In 1971, this building was sold to Congregation Adas Emuno, a Reform Jewish congregation from Fort Lee.

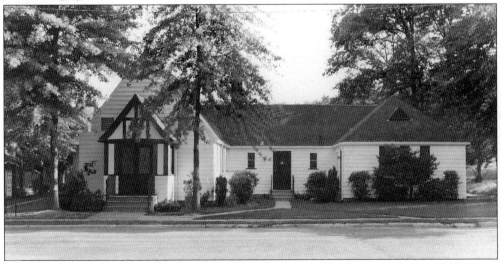

CALVARY LUTHERAN CHURCH, 1938. After the Leonia Lutherans split in 1928, those following the Missouri Synod built this English country-style church on Woodland Place, ending a decade of worship in the American Legion hall. Differences between the two Leonia Lutheran congregations continued until the two agreed to merge in 1969, with the new name Holy Spirit Lutheran Church.

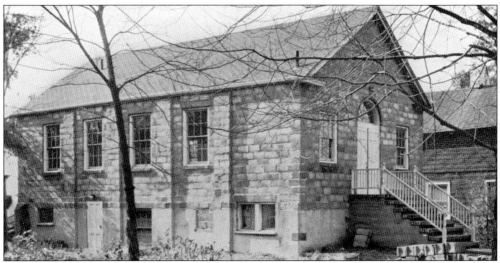

MOUNT ZION BAPTIST CHURCH. Leonia's African American community began worshipping together in 1928. They met in sheds, homes, and storefronts before they purchased land on Schor Avenue in 1938. Parishioners met twice weekly, on Wednesdays and Sundays, for services. The onset of World War II and the subsequent shortage of funds, manpower, and building materials delayed the construction of the building. Finally, it opened for services on Easter Sunday 1944.

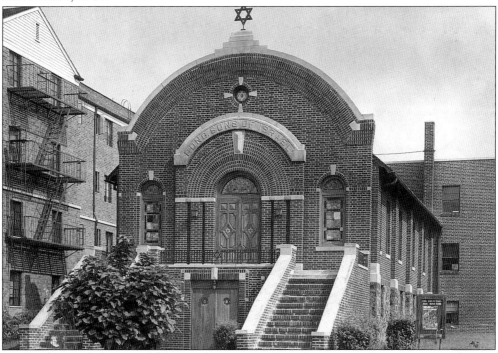

CONGREGATION SONS OF ISRAEL SYNAGOGUE. Jewish families from Leonia, Palisades Park, and Ridgefield first met for high-holiday services in 1920. For many years, Leonia's American Legion hall was used for services before they built this synagogue on Edsall Boulevard in Palisades Park. As their community expanded, they built a new temple in Leonia, on Grand Avenue, in 1964. Zelick Block was the rabbi for 44 years.

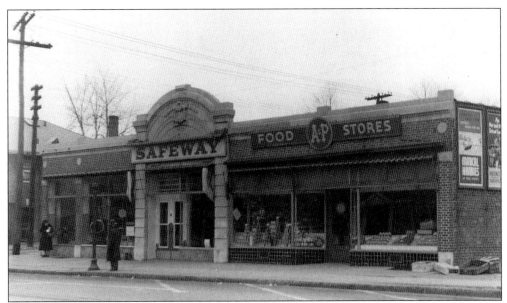

THE NORTHERN VALLEY CO-OP, 1947. The first building at the intersection of Fort Lee Road and Broad Avenue was built on the southeast corner. Modern Home Builders Nelson and Greenberg, who constructed many business establishments and homes in Leonia, built it. In 1944, a Safeway moved in. Later, the A & P market moved in next door. In 1937, 22 Leonia families formed a food-buying club called the Co-op. They started in small quarters at the north end of town but eventually replaced the A & P in 1947. In 1954, they replaced Safeway as well. By 1969, the Co-op had 2,200 members and revenues of $2.5 million. Much of the profit was used to provide funds for startup organizations in Leonia and to purchase works of Leonia artists, which were later donated to the Leonia Public Library. Competition from supermarkets resulted in the closure of the Co-op in 1983. The store later became Met Foods.

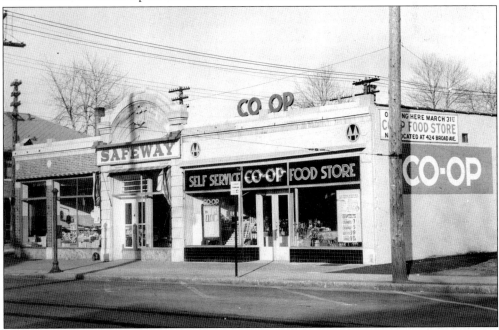

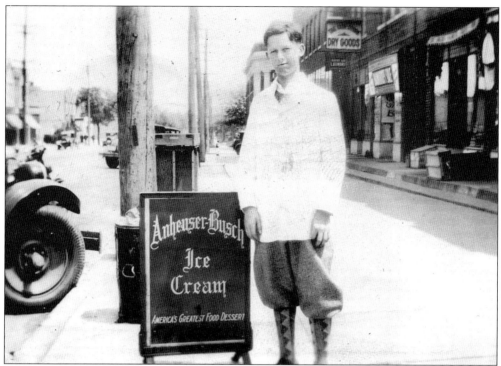

BROAD AVENUE BILLBOARDS. Young Secor Chace, who later became the state's youngest local fire chief (in 1942), is shown in front of the popular Ferrara's Gourmet Grocery Store, on Broad Avenue. He stands next to a sandwich board advertising Anheuser-Busch Ice Cream. Many residents complained about the overuse of sandwich board advertisements such as this one in the business district.

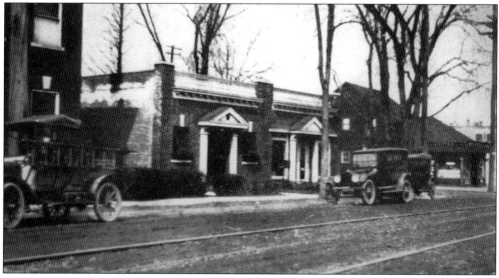

BROAD AVENUE AND FORT LEE ROAD. Shown is the new real-estate building on the southwest corner of Broad Avenue and Fort Lee Road. A second floor was later added to this building. On the left, out of the picture, was the Telephone Exchange Building, which later became borough hall. The Nelson Building had not been built yet on the northwest corner.

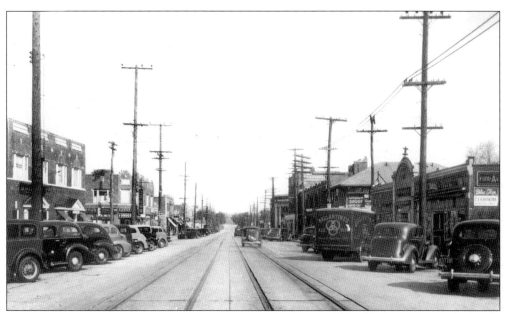

DOWNTOWN LEONIA, C. 1940. The businesses at the intersection of Fort Lee Road and Broad Avenue were built in the early 1920s. Shown are two views of downtown Leonia. Lesser's Drugs is on the northwest corner. Also seen is Whelan's Drugs. Signs on the truck advertise Ballantine Ale and Beer. The sale of liquor was not permitted in town until 1933. Taverns have never been allowed. Note the unsightly utility poles. They were removed in the 1950s.

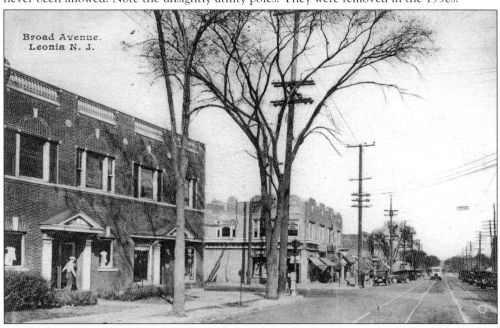

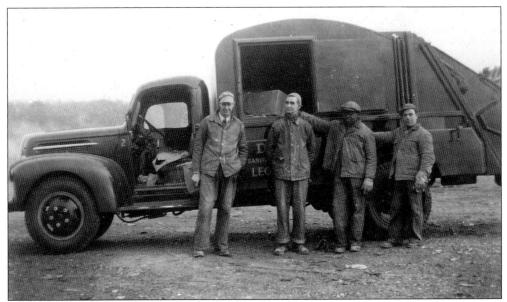

THE PUBLIC WORKS DEPARTMENT. A public works department was formed in 1923. Before that, townspeople were responsible for disposing of their rubbish, which usually meant burning it in their backyards or hiring private services. Initially, garbage was picked up with horse-drawn wagons. In 1929, two trucks were purchased. By 1930, the public works department provided garbage pickups three times a week and removed ashes from cellars. Unique to Leonia, the department picks up garbage at the back door.

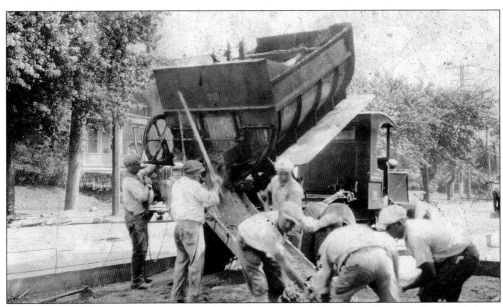

PAVING BROAD AVENUE, 1930. With all the dust generated by the trolleys, it is hard to believe that Leonia's main thoroughfare was not paved earlier, but the expense was a factor. Who would pay to pave it? Residents along Broad Avenue objected to footing the entire bill. After a compromise was reached, it was paved and a town celebration was held in the business district.

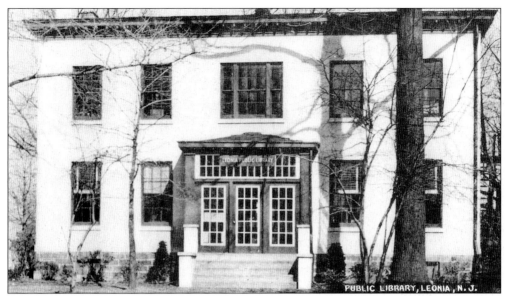

THE LEONIA PUBLIC LIBRARY. The Leonia Public Library was started in 1915 through a townwide effort. At first, it was privately funded through theatrical productions and other fundraisers. In 1923, residents voted to support it with taxes. That same year, the borough purchased the old Wood Homestead. Municipal offices were placed on the first floor, and the library occupied the second floor. In 1953, after the borough offices moved out, the library occupied the entire building. Cornelia Shedd was the head librarian; Alice Freas was the children's librarian.

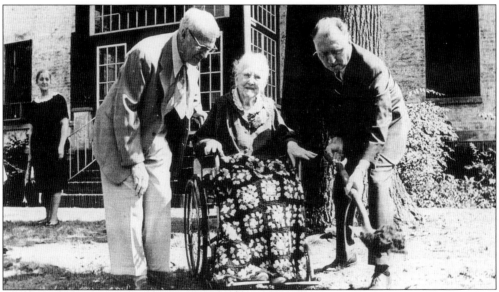

THE GROUNDBREAKING FOR THE NEW LIBRARY. In 1969, a new library was built adjacent to the old. Shown from left to right are library board president Alexander Wyckoff, Dr. Frances Bartlett Tyson, and Mayor Cassius Daly at the groundbreaking. Dr. Tyson, a major financial contributor to many worthy projects in town, donated $77,000 toward the construction of the new library. She preferred that the new library have a classic rather than modern style but gave her blessing nonetheless.

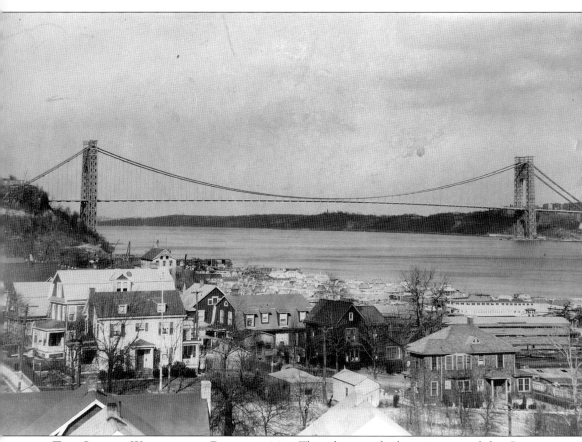

THE GEORGE WASHINGTON BRIDGE, 1931. This photograph shows a view of the George Washington Bridge from Edgewater. The photograph was taken the year the bridge opened. Leonia was "half full" by then, with a population of about 4,000. While the bridge was welcomed by most, many feared that relaxed zoning laws, apartment buildings, and an easier accessibility to the town might change its residential character. In the late 1920s, rival Republicans had major political battles over zoning and whether apartments should be allowed on Broad Avenue, Grand Avenue, and Fort Lee Road. One campaign pamphlet against relaxed zoning proclaimed, "Live in Leonia, Not on It." In 1930, a hit Broadway play called *House Beautiful*, by Channing Pollock, was based on Leonia. The play featured a mythical town near a big city that was threatened by the construction of a bridge. Channing was the brother of John Pollock, a former mayor.

Three
LEONIA LIFE

Leonia was settled in waves, and each wave of newcomers contributed to the improvement of Leonia. Those who came in the late 1800s set out to improve the schools and establish a borough form of government. They established ordinances that excluded taverns and funeral parlors and set strict zoning guidelines. The artists who came at this time succeeded in raising the appreciative level of art in the community. They painted murals, gave "chalk talks" to students, painted, and sketched Leonia scenes and people. They designed elaborate sets, costumes, and posters for Leonia's theatrical productions. Leonia's first African American families and European immigrants were entrepreneurs, setting up shops on Spring Street and Grand Avenue, providing much-needed services and skills. Professors, clerics, and businessmen, who formed and joined organizations of every type, also came to Leonia.

Artemus Ward's emphasis on creating a community that placed high values on educational and cultural standards as well as "social activities that made life worth living" attracted noted writers, professors, scientists, theater people, musicians, and religious leaders to Leonia. In 1934, Leonia had more residents listed in *Who's Who* per capita than any other city in the United States.

Newcomers relished the opportunity to handcraft a community and share their expertise in town affairs. They poured energy and talent into service organizations, religious activities, politics, social clubs, theatrical productions, school functions, musical events, and art shows that enriched and enlivened the town. The Men's Neighborhood Club planted thousands of shade trees in town. The Women's Club sponsored art exhibits and educated women on voting rights. Together, they started the Leonia Public Library. In 1919, returning World War I veterans formed the first American Legion in New Jersey. That year, the Players Guild of Leonia was started to raise money for the newly founded library. A Nobel Prize–winning chemist served on the board of education. After World War II, Leonians created one of the first volunteer ambulance corps in the country—the Lions Club bought the first ambulance. The town doctor started the first Girl Scout troop, and the town raised funds and donated services to build the scouts their own house. In the 1950s, with the mayor's leadership, all citizens mobilized to stop the federal government from putting an interstate highway through the center of town. The people of Leonia donated land to the county for a park. For 30 years, Leonians suspended the traditional way of electing candidates in order to promote harmony. Today's Leonia is the result of years of creative ideas, careful municipal planning and development, and a high level of citizen involvement. Giving one's all for the town was (and is) expected and is known as "the Leonia way."

Will Leonia Be Bombed?

THE Taxpayers FORUM — Nearness To Bridge And Big Industry Is Topic Of Argument

Defense Advocate

Morris Asks Payment Of Tax Levies — Collector Urges Holdouts

THE LEONIA LIFE NEWSPAPER. Leonia had enough news and advertising to sustain its own weekly newspaper, *Leonia Life*, from 1922 to c. 1970. Every organization in town, including the schools, contributed articles and photographs. Martha Rado, a Socialist, was the founder and editor from 1922 to 1937. Despite her personal politics, she enthusiastically endorsed many local Republican candidates in her editorials. Her daughter, Peg Rado Trapani, succeeded her as editor. In 1943, Mildred deBary became editor. In 1941, the headline "Will Leonia Be Bombed?" expressed concerns that if Britain fell, bombs aimed at the George Washington Bridge might miss their mark and fall on Leonia.

Reprinted from the BERGEN EVENING RECORD—*September 15th, 1922*

OFTEN CALLED "PERFECT HOME COMMUNITY"

Possesses Every Natural Advantage for Suburban Residences —Institutions All High Class

PROUD OF HER ARTISTS

Leonia is frequently called, "the perfect home community." There is no business in Leonia, except retail shops, necessary for the convenience of residents, and business is not wanted; in fact, a drastic zoning law has been passed to assure Leonia continuing as a residential community for some time to come.

As such a community it possesses every advantage. There are good schools, both grammar and high. Churches of four denominations, several clubs and any number of opportunities for social intercourse, but the big factor in Leonia's progress are its citizens. Although politically Leonia is by no means of one opinion, everybody in the Borough works and boosts for the Borough with the result that there is not a better kept town in Bergen County.

Leonia has good streets, good sewers, excellent police protection, a splendid fire department, fine parks, progressive officials, a low tax rate, and what is still more important, any number of able citizens ambitious for its future.

John Pollack is in his second term as Mayor of Leonia and the Council at present consists of John Graffe, Matthew Park, George Oliver, George S. Mills, E. D. McCracken, and H. A. Weber. Harry Ryder is the chairman of the Board of Education.

The Leonia high school is one of the finest institutions of learning in New Jersey, a fine building, fully equipped and with an excellent staff of teaching. There are three tennis clubs, a women's club, a men's club, a Shakespeare Club and an Arts Club, and any number of other social organizations.

The First National Bank of Leonia is one of the most successful banks in the State.

The first American Legion Post of the State belongs to Leonia; the Glen Dennan Newell Post being Post No. 1.

There is a large colony of artists in Leonia and once a year they produce an art exhibit of exceptional merit. Probably nowhere else in the State can it be duplicated. The Arts Club is another unique organization and under its auspices many well known actors, authors, singers and artists have been seen and heard.

Transportation facilities are ideal. There are three trolley lines passing through the Borough which make it accessible at any time of day or night to any place, and in addition there is the Erie Railroad.

Leonians are contented householders and they have every reason to be because nowhere else can there be found the same comfort coupled with the same number of opportunities for diversion.

THE BERGEN RECORD. This 1922 article on Leonia, reprinted from the *Bergen Record* and included in real-estate brochures, discusses Leonia's art colony and the emphasis placed on remaining a residential community.

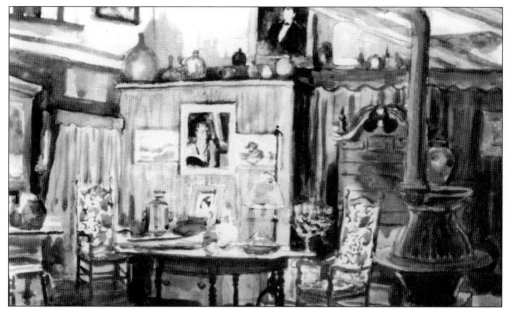

FRANK STREET'S STUDIO IN THE BARN. A number of Leonia artists, including Frank Street and Grant Reynard, rented barns that served as both their homes and studios. Shown is the inside of Frank Street's "studio in the barn," at the rear of 505 Grand Avenue. Street was a commercial illustrator for magazines such as *Cosmopolitan* and *Colliers*. He also taught at Leonia's amateur art school. (Painting by Grant Reynard; courtesy of Robert Fuller.)

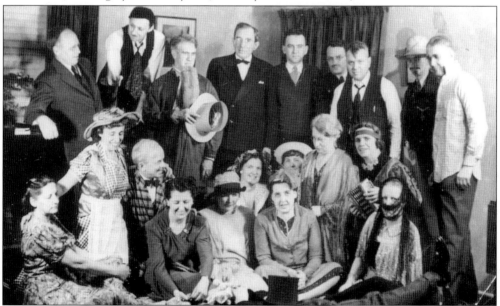

A PARTY, C. 1944. Festive parties were routinely held in homes and studios of Leonia artists. Shown at a masquerade party are a number of Leonia's artists and academics, including Harriet and Rutherford Boyd, Ralph and Alexa Fuller, Grant and Gwen Reynard, Frank and May Street, and Arthur Mitchell. Artists involved themselves in every aspect of community life. Their homes and studios could be identified by large studio windows that faced north. (Courtesy of Robert Fuller.)

GRANT REYNARD. Grant Reynard was a prominent painter and etcher who left magazine illustration to go into fine art. After studying at the Art Institute of Chicago, he came to Leonia to study under Harvey Dunn and Charles Chapman at the Leonia School of Illustration. He and his wife, Gwen, lived in the Wragge barn before they purchased a home farther up the block on Christie Heights Street. He later built a studio in the backyard. Reynard was elected to the National Academy of Design and became the president of the board of the Montclair Art Museum.

CHARLES CHAPMAN, SELF-PORTRAIT. Charles Chapman, who was elected to the National Academy of Design, was actively involved in the Leonia art scene from 1909 to 1962. He taught at the Art Students' League and the National Academy of Design. He painted a range of subjects, including the Grand Canyon mural for the Natural History Museum and biblical scenes for the Leonia Methodist Church. In 1914, founded the Leonia School of Illustration. He was also a consultant for the annual Leonia Art Exhibits, sponsored by the Women's Club. He worked out of his home and studio at 156 Sylvan Avenue.

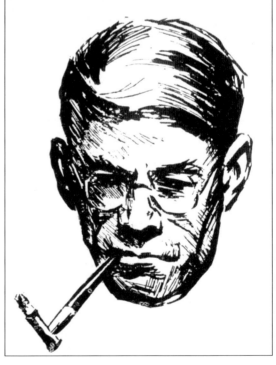

HARRIET AND J. RUTHERFORD BOYD. Harriet Repplier Boyd and Rutherford Boyd, both renowned artists, moved to Leonia in 1916. Rutherford had been the art director at five magazines, including *Ladies Home Journal*. Harriet painted portraits and miniatures. They invested their life savings in the historic Cole house, built a large artist's studio on the east side of the home, and landscaped their backyard with rock gardens, ponds, fountains, and walkways. Their home, called Boydsnest, was a social center in town. Clubs regularly met in the studio or in the yard, and the Boyds entertained every weekend with sing-a-longs, card parties, and plays. Harriet Boyd and son David taught art classes in the studio. (Portraits by David Boyd.)

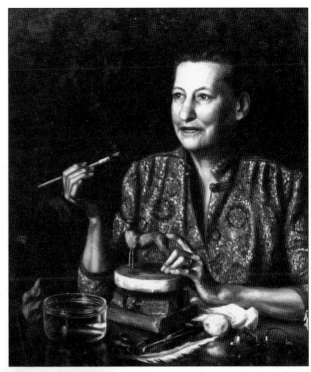

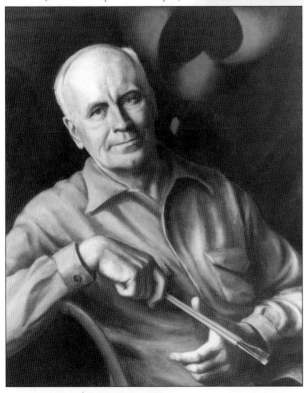

Sculpture

The Wolf	Andreas J. Andrews
The Awakening	"
Morning	Gerhard Schmidt
Creation	"
Lenore	"
Walkure	"
Rothenberg	Gerlot Schmidt
Roman Bath	"
Dancer	F. E. Hammargren
Oriental	"
Sea Horse	"
Meditation	"
Norma	"

EXHIBITION BY LEONIA ARTISTS

LEONIA GRAMMAR SCHOOL

APRIL 11 - 19, 1936

Auspices Leonia Woman's Club

Also

ORIGINALLY DESIGNED CRAFTS
PHOTOGRAPHS, BOOKS and
ARTICLES WRITTEN by
RESIDENTS of LEONIA

A LEONIA ART EXHIBIT, 1936. For more than 30 years, the Leonia Women's Club sponsored an annual art exhibit at the elementary school, featuring the works of Leonia's professional artists. Typically, 400 to 500 works of art were on display. Besides art, the exhibit also featured photographs, books, and writings of Leonians, as well as lectures, receptions, crafts demonstrations, and musical performances.

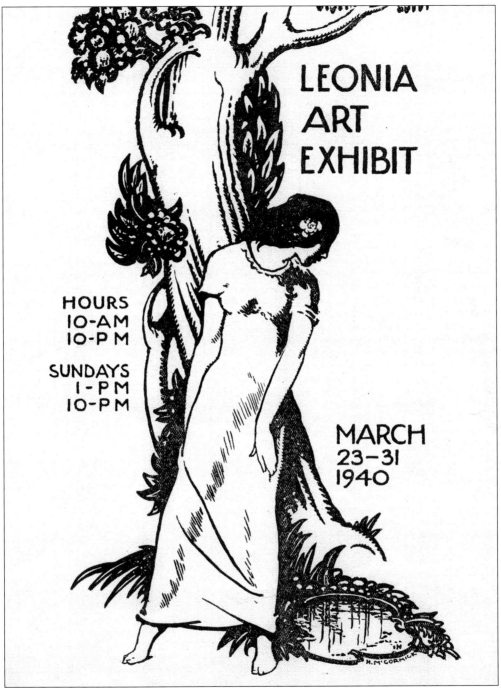

A LEONIA ART EXHIBIT, 1940. Leonia was home to more than 90 professional artists, including Grant Reynard, Harvey Dunn, Charles Chapman, Howard McCormick, Clara Elsene Peck, Rutherford and Harriet Boyd, Harry Eaton, Peter Newell, Ilona Rado West, J. Scott Williams, Keith Williams, Mahonri Young, Lynd Ward, Harry Wickey, Ruth Moore, Frank Street, Richard Paulie, Enos and Frances Comstock, Arthur Covey, John Stuart Curry, Arthur Mitchell, and Dean Cornwell. Many of these artists achieved election to the National Academy of Design.

THE PLAYERS GUILD OF LEONIA. The Players Guild was formed in 1919, building on a long theatrical tradition in Leonia. For 27 years, the the group performed at the schools and used homes for rehearsals and storage. From 1956 to 1993, the actors performed at Davidson Hall in the All Saints parish house on Park Avenue. One of the group's many firsts was the world premiere of the proposed Broadway production *Zadig*. When the play was produced on Broadway later that year, the costumes and sets designed by the Players Guild were used. In 1976, the Players Guild began a 25-year tradition of producing summer plays that were put on in the park. Shown is a program for the 1942 production of *The Pursuit of Happiness*.

RICHARD CECIL POND AND ALEXANDER WYCKOFF, 1956. These two founding members of the Players Guild contributed much to making each production a phenomenal success. Wyckoff was a noted author, artist, scenic designer, dress historian, and pioneer in the nation's little-theater movement. Pond was a noted art director and set designer. Here, they are shown at the All Saints parish house ribbon-cutting ceremony.

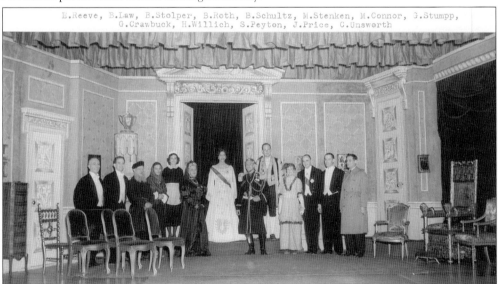

ANASTASIA, AT ALL SAINTS EPISCOPAL CHURCH. The Players Guild's first performance on the All Saints stage was *Anastasia*, featuring Mary Connor, Marion Stenken, George Crawbuck, Edward Reeve, Wallace Peyton, Colin Unsworth, J.B. Price Jr., and William Law. The play, which had a technical crew of more than 100, was sold out for all performances. All Saints was home to the Players Guild until 1994. In 1993, the group entered into a long-term lease to restore and renovate the Civil War drill hall. Today, the Players Guild is the oldest continuously running community theater in New Jersey and the third oldest in the nation.

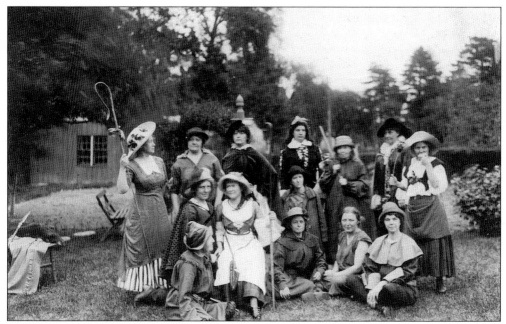

THE LEONIA SHAKESPEARE CLUB, C. 1915. Shakespeare was a favorite among Leonians, and Twelfth Night parties were annual events that attracted attendees from all over the metropolitan area. Members of the Housewives League, the Women's Club, and the Players Guild regularly performed his works. Above, the all-female cast of *As You Like It* performs in a meadow in 1915. Below is a performance of *A Winter's Tale*. Arpad Rado, the director of Leonia's Euterpe Orchestra, conducted the music.

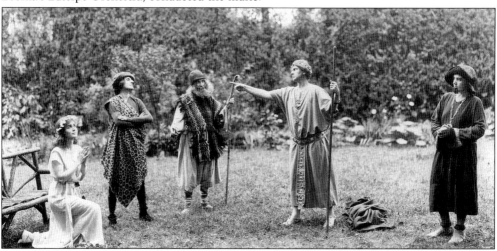

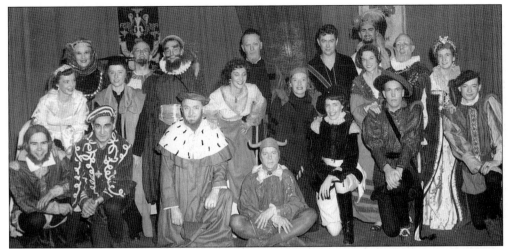

AN EVENING OF SHAKESPEARE, 1954. Presented by the Players Guild of Leonia, cast members are, from left to right, as follows: (front row) James Clark, Peter Trapani, Charles Metzler, Roy Andrews, Mary Connor, Don Victorin, and Albee Stecker; (middle row) Beverley Blood, Jean Toddie Meissa, Brooksie Callahan, Elaine Youmans, Bea Schultz, Ed Reeve, and Helen Willich; (back row) Olga Yeager, William Law, Jack O'Connell, Burton Reid, Peter Youmans, and Jack Callahan.

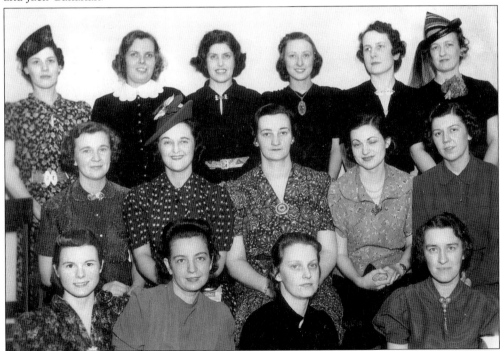

THE GLEE CLUB, 1939. This glee club was part of the Junior Women's Club. The members are, from left to right, as follows: (front row) Mrs. Stanley Olpp, Mrs. Wilfred Simeral, Mrs. John Harwood, and Helen Joyce; (middle row) Mrs. McPherson Beall, Mildred David, Hilda Burton, Mary Wagner, and Lillian Boelkholt; (back row) Mrs. Otto Porwell, Mrs. William Speer, Evelyn Tyson, Adele Schwald, Mrs. Frank Bogert, and Mrs. LeRoy Osborn. The Junior Women's Club also created a pageant called *Legend of Leonia*.

87

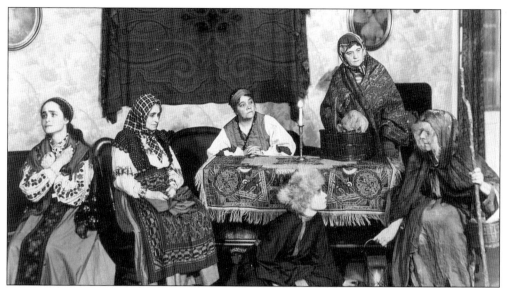

THE LEONIA WOMEN'S CLUB, 1932. The Women's Club was one of the most active organizations in town, with committees on government, music, theater, art, social services, and literature meeting every night of the week. In 1932, the club, which had an active drama and Shakespeare department, wrote and presented a play called *Babouscka*, which took first place in the New Jersey Women's Club playwriting competition. The actresses were Mary Edmondson, Ada Chapman, Mrs. Halsey O'Connor, Betty Williams, Peggy Anderson, and Mrs. George Finch.

CHAPMAN'S POSTCARD FOR BABOUSCKA. To help promote the play, Charles Chapman created pastel sketches of each actress in *Babouscka*. Oftentimes, artists whose work was regularly featured in the leading magazines of the day volunteered their talents to design posters and programs to promote Leonia theatrical events.

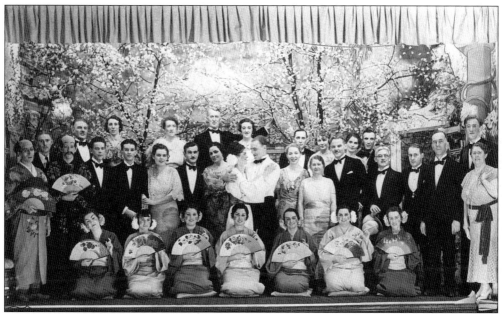

PRESBYTERIAN CHURCH OPERETTAS. During the 1930s, members of the Presbyterian church performed an annual operetta on the stage of the church social hall. Church member Emily H. Hill (far right) directed these productions. Her daughter Anne Hill McGavack (center), who was trained at the Metropolitan Opera, performed the lead female roles opposite baritone Wes Vreeland. Here they are shown in the production *Cherry Blossom*.

Men's Neighborhood Club
LEONIA, NEW JERSEY

LADIES' NIGHT
Friday Evening, April the Eleventh, 1919, at Eight-fifteen

An attractive program will be presented. Music, instrumental and vocal. Refreshments.

Executive Committee meeting at 8 o'clock.

Mr. Gowans, Chairman of the Gardens Committee, is pleased to answer your questions and help solve your difficulties.

Look for the table of seed catalogs.

DAVID C. MacCLATCHEY; President.
WILLIAM W. SHEDD, Secretary.

THE MEN'S NEIGHBORHOOD CLUB. The Men's Neighborhood Club was formed in 1911 and lasted well into the 1960s. The group held monthly meetings at the Leonia Presbyterian Church "to promote any and all interests which tend toward the advancement and general welfare of the citizens of Leonia." In addition to having guest speakers, members planted trees in town and held annual dahlia fairs, harvest exhibits, art shows, hobby shows, and minstrel shows.

ELIZABETH VANN, WPA DIRECTOR. Elizabeth Vann moved with her husband, Eugene, to Leonia from Virginia in 1923. In 1925, five years after women received the right to vote, she organized the Bergen County Women's Democratic Club. During the Great Depression, she became a director of the New Jersey WPA, supervising surveys of historical records, new publications, the production of school murals, and a number of other professional and engineering activities. She was able to provide meaningful work during the Great Depression for many Leonians. Two other influential Leonians in the WPA were Viola Hutchinson, supervisor of the Federal Writers Project for New Jersey, and George Needham, supervisor and conductor of the WPA Bergen County Orchestra. A member of the Daughters of the American Revolution (DAR), Elizabeth Vann gained national notoriety when she protested the DAR clause that said only white artists could perform in Constitution Hall. A year after Marion Anderson was prevented from singing, the clause was changed, due to the efforts of Vann. (Portrait by David Boyd.)

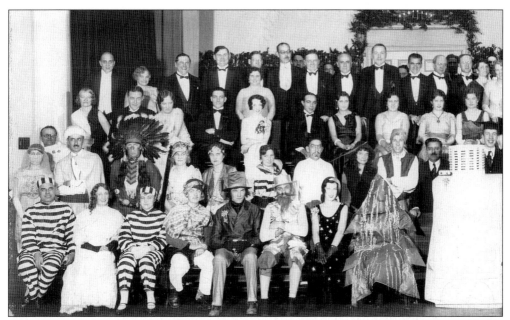

A NEW YEAR'S EVE PARTY, 1929. Parties were held often in Leonia's homes and social halls. In these images, many of Leonia's leading citizens are gathered on the stage of the Leonia Elementary School for a New Year's Eve party in 1929. Decorations were put together by Richard Pond. The stock market crash occurred just two months earlier, in October. Initially, Leonia was immune to the Great Depression. Later, however, some 100 families were without breadwinners, and the borough provided financial and material assistance. Many Leonia artists, writers, and musicians participated in WPA arts projects, painting murals, writing local histories, and conducting orchestras.

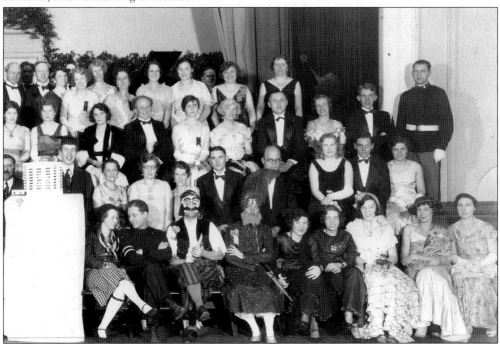

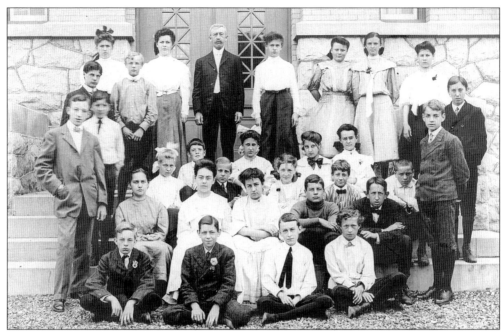

A GRAMMAR SCHOOL CLASS, 1907. In 1907, the grammar school was still new, undergoing continual expansion and hiring new teachers. As there was no high school, these students either entered the work force after graduation or attended private high school in New York City. This is one of the earliest class photographs on record. The principal, L.L. Rosenkrans, stands in back.

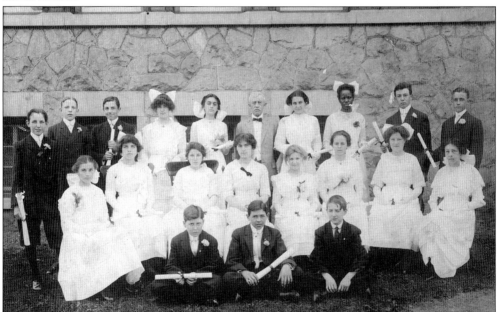

AN EIGHTH-GRADE GRADUATION, 1912. Decked out in their finest suits and white dresses, these students hold their diplomas with pride. A few would go on to Leonia High School, which opened in 1913. At that time, secondary school was optional. The year before the new high school building was complete, high school classes were held in the grammar school.

ELEMENTARY SCHOOL TEACHERS, 1917. As enrollment grew, new teachers were hired. Teachers in the early 1900s could not marry. Most boarded with families, as early Leonia did not have apartments. Rebecca Gismond is fifth from the right. Anna Creighton Scott is fourth from the right. Scott later served as principal of the elementary school until her death in 1955. After she died, the school was renamed in her honor and her portrait hangs at the entrance of the school.

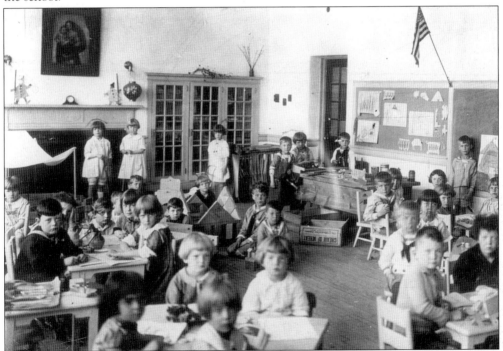

A KINDERGARTEN CLASS, 1926. Kindergarten was a magical place at the Leonia Elementary School. The huge room had a fireplace, wooden blocks, dolls and dollhouses, real tools (such as saws and hammers), easels and paint, and shelves full of books. Many of these books were presumably written by Leonians such as Peter Newell, who wrote *The Hole Book* and *The Slant Book*. Leonia also had two other noted children's authors, Mary McNeer and Ginny Colman.

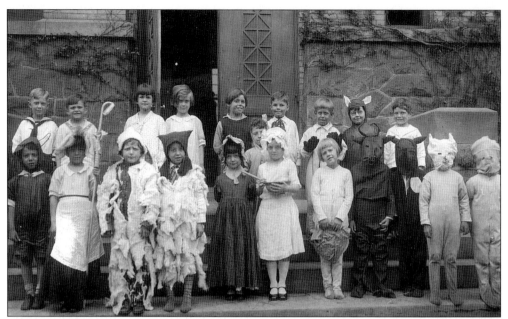

A School Play, 1924. An appreciation of the theater began early for Leonia children. School plays were much-anticipated events, and parents with connections in the theater and the arts often helped with the productions.

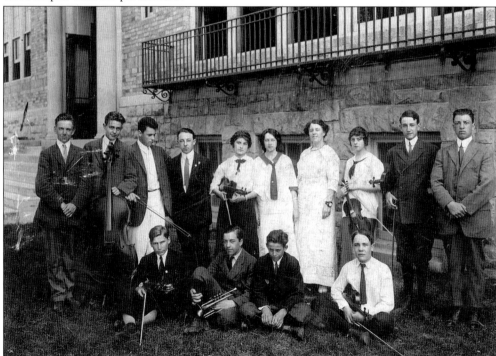

The Leonia High School Orchestra, 1914. Leonia schools have always placed a high emphasis on the arts. In the center of the photograph, holding a violin, is Doris Hurd (Faig), whose music career was short-lived, as she had to leave school to help her mother manage the home. In 1918, her mother died of the flu, leaving Doris in charge of raising her siblings.

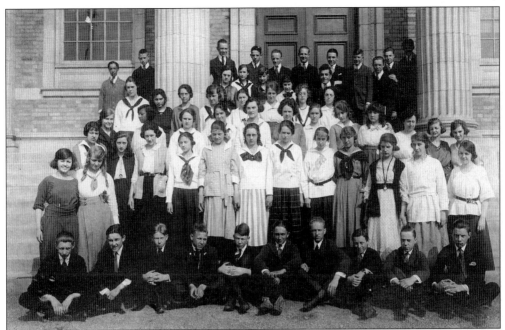

THE LEONIA HIGH SCHOOL CLASS OF 1922. Shown is the Leonia High School graduating class of 1922. Two of its members from the girl's track team represented the United States at the International Track Meet in Paris. The girls, Maybelle Gilliland and Elizabeth Stine, both broke world records at the qualifying meet. Despite a string of winning interscholastic teams, the board of education voted to replace interscholastic sports with an intramural program for girls in 1925. It was not unusual for 200 girls to participate in an intramural sport such as soccer. Women athletes did not compete interscholastically again until 1972.

LEONIA SECTION

HIGH SCHOOL GIRLS' TEAM PROVE THEMSELVES TO BE GREATEST WOMEN ATHLETES IN NATION; TWO WILL REPRESENT U. S. A. AT MEET IN PARIS

Elizabeth Stine Breaks World Record For Hop-Step-Jump; Mabel Gilliland, Lula Hopper, Janet Hobson, Martha Nyquist and Edith Easton Win Honors

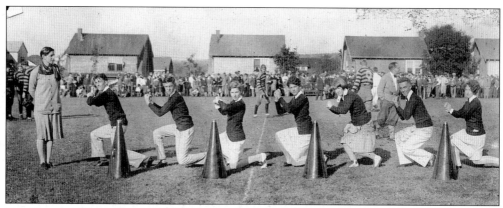

THE LEONIA HIGH SCHOOL CHEERLEADERS, 1928. These cheerleaders, male and female, cheer for the football team at the dedication of the Dobelaar Field in 1928. The schools purchased the land in 1926, and the athletic field was a welcome addition to the high school. In the background is Vreeland Avenue.

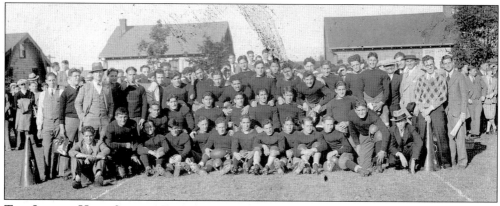

THE LEONIA HIGH SCHOOL FOOTBALL TEAM, 1928. Leonia High School did not have a winning football team until 1944, but that did not keep the crowds from Dobelaar Field. Everyone in town attended the football games. The annual homecoming game and bonfire was a much-anticipated event. Other interscholastic sports for boys included wrestling, basketball, and baseball.

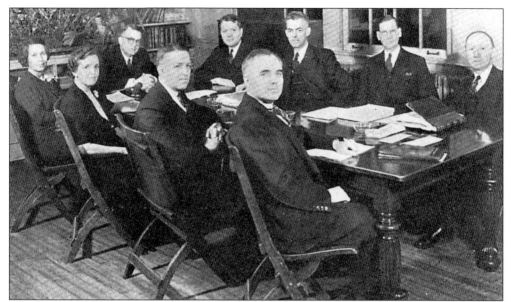

THE LEONIA BOARD OF EDUCATION, 1939. A number of notable Leonians served on the board of education, including 1934 Nobel Prize winner Harold Urey (second from right in front). He received the award for his discovery of heavy water, an essential component in the development of the atom bomb. Urey said he liked Leonia because it was a community of "average people like us."

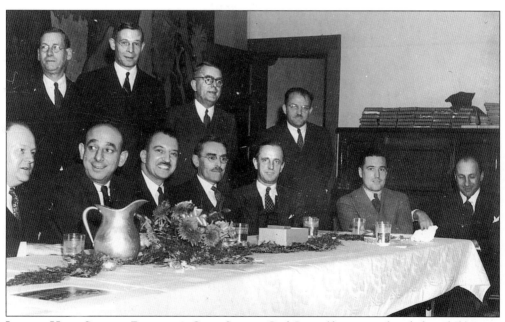

LEONIA HIGH SCHOOL PRINCIPAL CARL SUTER. Carl Suter (front row, fourth from left) was a history teacher at Leonia High School and, from 1935 to 1958, served as principal. Here, he is being honored by fellow teachers at a banquet c. 1950. Among those identified are physical education teacher David Jones (front, second from right), Nelson C. Smith (back left), and Roy Nickerson (back right).

The LEONIA CIVIC CONFERENCE

ORGANIZED AUGUST 7, 1939

Its PURPOSE

Its OBJECTIVES

Its RECORD

Why Is Leonia Local Government Different?

THE LEONIA CIVIC CONFERENCE. For much of the 20th century, Leonia's political life revolved around an organization known as the Civic Conference. In a town where Republicans outnumbered Democrats three to one until the 1970s, and with many insisting that political affiliation should have no place in community service, the Civic Conference was organized in 1939. This group, which was made up of representatives from the borough's organizations (including the local Democratic and Republican organizations), nominated the ablest candidates for mayor, council, and school board, regardless of party affiliation. This "gentleman's way of conducting politics," was frequently challenged and was called un-American by some. Nonetheless, the candidates it endorsed were elected until the early 1970s.

MAYOR DUDLEY ALLEN. Four-time consecutive mayor of Leonia, Dudley Allen was remembered for three major events. He convinced the federal government to build a federal highway around Leonia and not through it (see the map below). He led the movement to create the 812-acre county park along Overpeck Creek. Finally, he was the only mayor to be elected to four consecutive terms, from 1950 through 1957. He also had the utility poles removed from the business district in the early 1950s, as part of a beautification program.

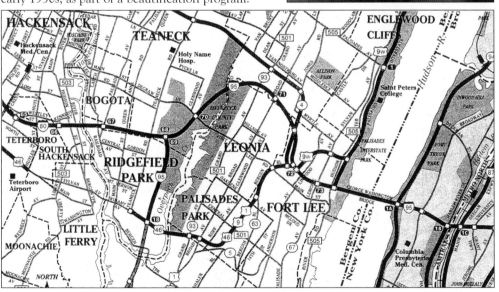

LEONIA MAYORS, 1982. Although Leonia's first mayor, Cornelius Christie, was a Democrat, most mayors after him were Republican. During the first half of the 20th century, Leonia was a Republican town, with a few "suspected" Democrats. Mayors elected from 1939 until 1972 were Republicans endorsed by the Civic Conference. Shown from left to right are Republican Mayors Joseph Foley, Harry Moore, Arthur Jones, John Stenken, Cassius Daly, and Dudley Allen. By the 1970s, Democrats predominated. Leonia's first Democratic mayor was Thomas Ford, elected in 1972. The first instance that an all-Democratic mayor and council were elected occurred in 1984, under Robert Pacicco.

WOMEN IN POLITICS. After New Jersey women received the right to vote in 1920, two Leonia organizations educated women about voting rights and politics. Beginning in 1919, Margaret Porch Hamilton, a pioneer in civic education for women, led the Forum, an offshoot of the Women's Club. More than 30 years later, in 1952, Nancy Hawkins and Jane Davis started the League of Women Voters in Leonia. Nancy Hawkins (seen here), a Democrat, was the first Leonia woman to run for state assembly, in 1955. The first female mayor was Elizabeth Dwarica, elected in 1988.

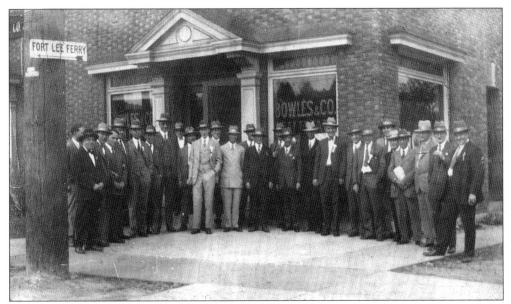

THE BOARD OF TRADE, 1927. The Leonia Board of Trade was formed in 1924. Among its goals was the creation of an attractive business district. The members are shown getting ready to attend the groundbreaking ceremony for the Interstate Hudson River Bridge (later called the George Washington Bridge) in September 1927. Members included Theodore Willich, founder of Leonia Bank and Trust; Robert B. Hanson, chairman of board at Leonia Bank and Trust; Bernard Nelson, builder; and C. J. Kirkland and Ralph Day, real-estate agents.

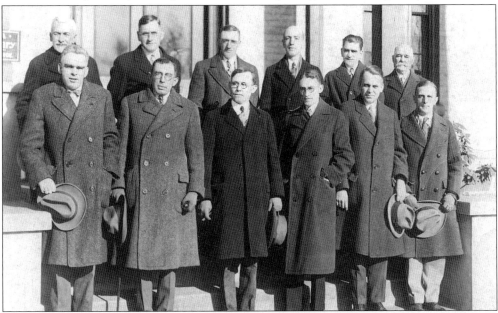

THE LEONIA PLANNING BOARD, 1928. This photograph shows the first planning board. Many of the issues they dealt with involved zoning. One of their first tasks was to create a master plan for the borough. All plans for subdivisions had to be approved by the planning board. Among the first members were Harry E. Moore, George Strehan, F.W. Loede Jr., Mrs. William Haller, Dr. Arthur Hixson, and George Mills.

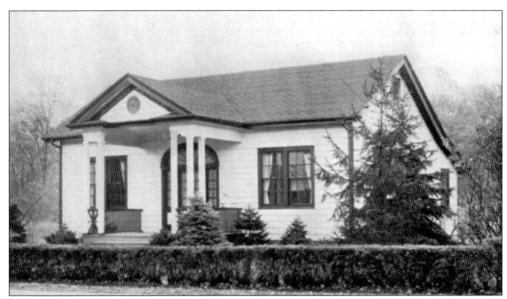

AMERICAN LEGION POST NO. 1. In 1919, after the conclusion of World War I, a group of Leonia veterans gathered to form the first American Legion organization in New Jersey, the fifth in the nation. Veterans Leroy Iserman and Alexander Wyckoff wrote the Leonia chapter's constitution and bylaws, which were later adopted by the national organization. The veterans constructed this hall on Broad Avenue in 1924. An addition was built in 1948. The post was named after deceased veteran of World War I, Clendenon Newell, the son of artist Peter Newell.

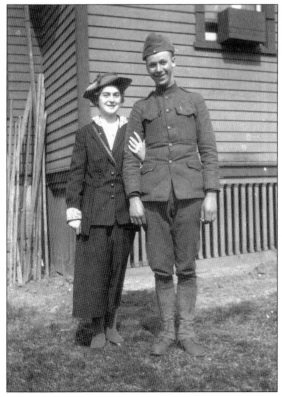

A WORLD WAR I SOLDIER. Shown are Doris Hurd and cousin Orison B. Sloat. A total of 167 Leonians served in World War I. Seven of them died. Many of Leonia's young men went overseas as part of Dr. Talmage Wyckoff's medical unit. The soldiers in Europe battled with influenza, mustard gas, pre-penicillin infections, trench foot, and other health issues. Those they left behind in Leonia battled primarily with the influenza pandemic, which killed 40 million people worldwide.

THE MEMORIAL PLAQUE. Out of a population of 6,000, a total of 721 Leonians served in World War II. In Wood Park, Leonians erected a stone memorial dedicated to all those who served and made the ultimate sacrifice in World War I (7), World War II (22), Korea (5), Vietnam (1), and Desert Storm.

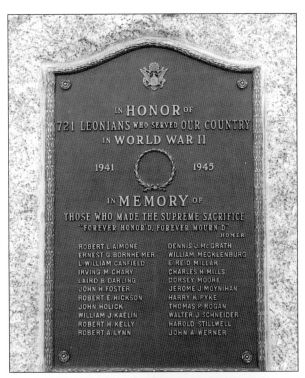

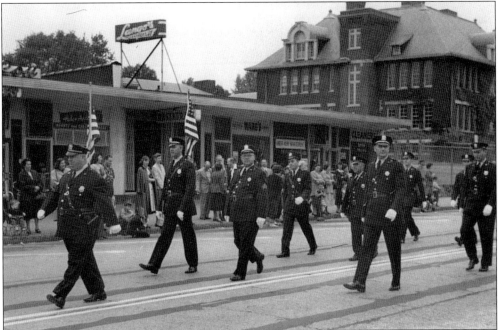

A MEMORIAL DAY PARADE, 1950. Each year, the American Legion sponsors a Memorial Day parade on Broad Avenue to honor those who served their country in wartimes. Shown is the Leonia Police Department marching north on Broad Avenue. In the background is the elementary school, which was burned in 1974 and was later demolished, and the mini-mall, which was built in the late 1940s.

GEORGE COLEMAN, U.S. ARMY. There were 30 blacks from Leonia who served in World War II. Shown is S.Sgt. George Coleman of the U.S. Army's 526th Port Battalion, an all-black unit that served in Okinawa and the Philippines. The armed services were not integrated until the end of the war, under the direction of Pres. Harry Truman. George Coleman worked as an engraver at Bendix for 33 years and was one of the company's first black employees.

THE LEONIA CIVIL DEFENSE FIRST AID SQUAD, 1941. During World War II, Mayor Wilbur Osler appointed the Civil Defense Council with a budget of $17,000. Members met every Saturday morning for drills. While Japanese Americans on the West Coast were placed in detention camps, Leonian Yaeko Nakayama (front, right) was an active member of the Civil Defense Council. Others in the photograph include, from left to right, the following: (front row) Leonard Baker, two unidentified, and Charlotte Forsthoff; (middle row) George Finnie, Harriet Faig (Hoenie), Louise Pratt, Wes Vreeland, and Stuart Kirkland; (back row) C.K. Spencer, John Fillmore, and two unidentified.

RED CROSS VOLUNTEERS, 1941. Leonians volunteered in all capacities to help the war effort—rolling bandages, recycling scrap metal, saving the tin from gum wrappers, and sending care packages overseas. These Red Cross volunteers met regularly to do their part. They include, from left to right, the following: (front row) Doris Faig, Marie Hauptman, Martha Louise Oliver, Olive McDermott, and unidentified; (back row) Helen Baker, Betsy Spencer, unidentified, Ethel LaMer, and Ruth Kirkland.

LEONIANS DEVELOP THE ATOM BOMB. In 1945, the day after the atomic bomb was dropped, two of Leonia's five Nobel Prize winners, Enrico Fermi and Harold Urey, were featured in the *Bergen Record* for their work on the bomb. Both lived in Leonia and taught at Columbia University. In 1942, Fermi moved to Chicago to lead the Manhattan Project research team that developed the bomb. Four Leonians ultimately worked on the project: Fermi, Urey, Henry Boorse, and Nobel Prize winner Willard Libby. Other Leonian Nobel Prize winners were Maria Mayer and I.I. Raby.

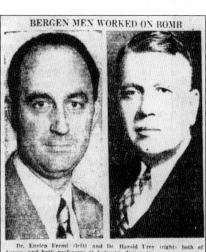

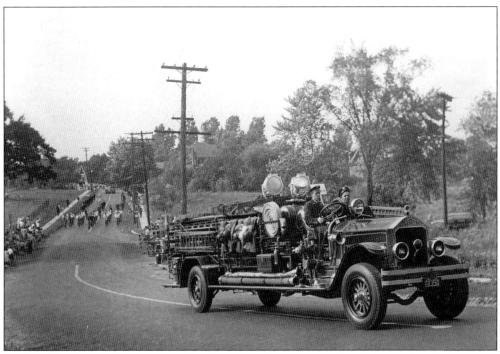

A FIRE ENGINE ON PARADE, 1938. Volunteer firemen Art Van Zilen and Jack Lewis are shown driving Leonia's 1927 hook and ladder in a parade. The parade was not held in Leonia.

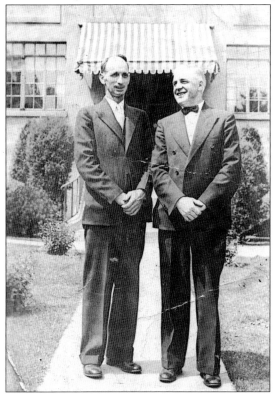

CARL SUTER (LEFT) AND SID DAVIS. Shown are Carl Suter, principal of Leonia High School, and Sidney Davis, fire chief. When Davis joined the fire department in 1923, the firehouse was located on Irving Street (now Gallone Memorial Park). It was located there to allow the horses to travel downhill to the fire rather than uphill. He was a lifelong member of the fire department and worked as the borough mechanic for 45 years. He also built and painted much of the early playground equipment for the town's parks.

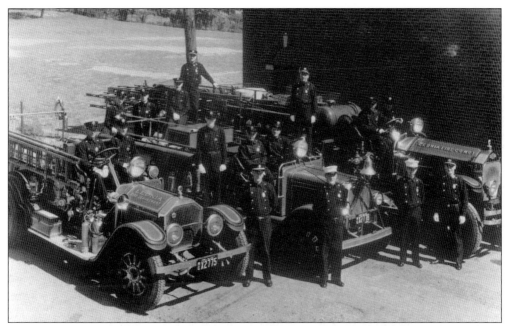

THE VOLUNTEER FIRE DEPARTMENT, C. 1930. Shown are members of the fire department and their firefighting equipment in the 1930s in Wood Park. Fire hydrants and water pipes were installed in 1895, replacing the old bucket brigades from the 1800s. William Richards, the builder of many of Leonia's homes, donated the first fire engine, a Cadillac.

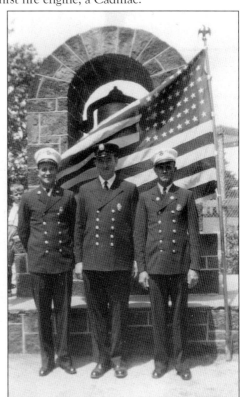

THE FIRE BELL, 1947. In early Leonia, before sirens, residents rang a large bell if they spotted a fire. A horse with drag ropes pulled the first hose cart. Shown in front of the old fire bell after the Memorial Day parade of 1947 are, from left to right, volunteer firemen Bert Tatro, Willie Nestlein, and Gerard Tatro.

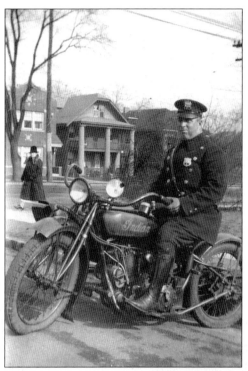

THE POLICE DEPARTMENT, C. 1925. In 1895, Sidney Conklin was appointed the first borough marshal. He requested and was given handcuffs, a revolver, and a cage—he did not specify whether he needed the cage for stray dogs or unruly citizens. In 1918, Leonia's uniformed police department was formed. Initially, they had one car and this Indian motorcycle that was used to patrol the back alleys and the Overpeck Creek area. The department stopped using motorcycles in 1928 but resumed using them in 1999. Shown is Patrick Clarkin.

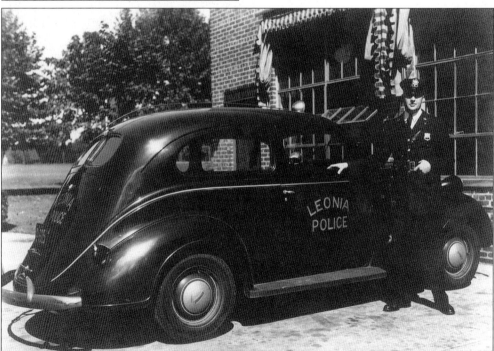

A POLICE CAR, C. 1939. Police officer Paul Minerly is shown in front of a 1939 Plymouth police car. Minerly was a grandson of one of the first town marshals. In 1939, the police chief made $3,000 per year and a patrolman made $2,000. The work schedule in the 1940s was 14 days on and one day off. By 1960, they worked six days on and had two days off.

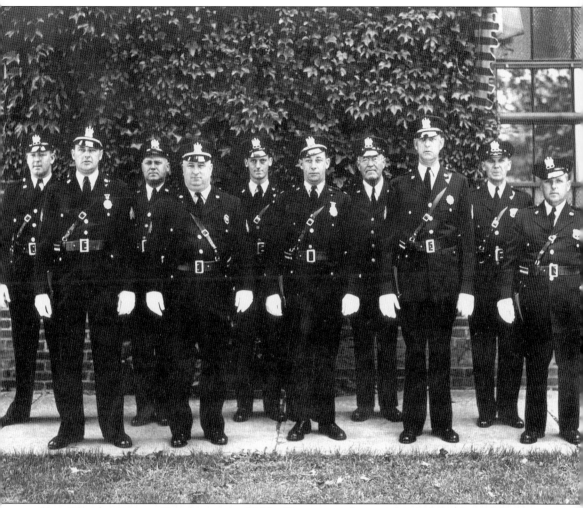

THE LEONIA POLICE DEPARTMENT, 1946. Shown are the members of the Leonia Police Department in 1946. They are, from left to right, as follows: (front row) Paul Minerly, Patrick Clarkin, Chief George Van Zilen, Paul Van Wyck, and Arthur Pfeiffer; (back row) James Brazee, Samuel Watson, Secor Chace, August Beaton, and unidentified. The photograph is unique in that it shows four police chiefs: Brazee, Clarkin, Van Zilen, and Van Wyck. Leonia hired its first African American police officer, George Boyd, in 1949. It hired the first policeman with a college degree, Carmey Cross, in 1973. It hired its first woman police officer, Heather Murphy, in 1995. Leonia was one of the first police departments in the state to require college degrees.

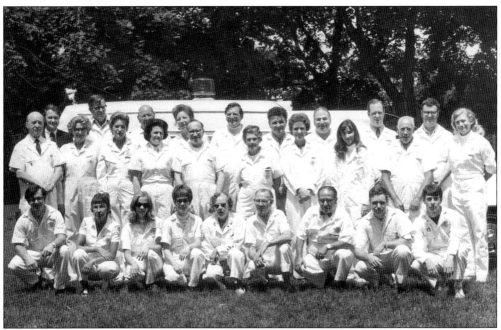

THE LEONIA VOLUNTEER AMBULANCE CORPS. In 1945, Leonians started a trained volunteer ambulance corps. The Lions Club raised funds to purchase a fully equipped Ford ambulance. In 1952, the Leonia Ambulance Corps was profiled in the *Saturday Evening Post,* later reprinted in *Readers Digest.* Seen above are members of the ambulance corps in 1973. Below is ambulance corps member and former star of 100 silent movies Priscilla Dean Arnold in front of the second ambulance.

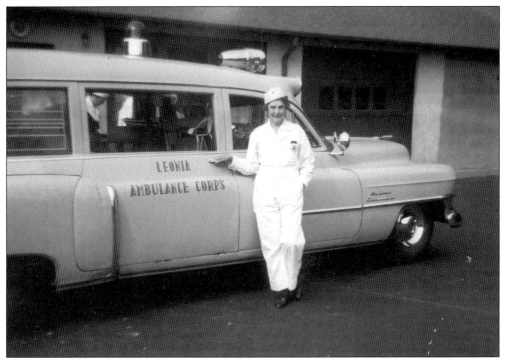

THE BOY SCOUT COURT OF HONOR, 1948. The Boy Scouts started in Leonia in 1910. Four troops were then chartered in the 1920s, including Troops 71, 72, 74, and 37. The first Cub Scout pack was formed in 1940. At its peak, Leonia had eight active Boy Scout troops. The Leonia Lions Club, various churches, the American Legion, and the Men's Neighborhood Club sponsored the troops.

BOY SCOUTS, POST 96, 1948. The Boy Scouts were very active during World War II. They collected salvage for the war effort. Shown from left to right are the following: (front row) Walter Bergler, Fred Stickle, Donald Joyce, Henry Hansen, and Robert Shanno; (back row) Rudolph Staehle, David Cohen, Rev. J. McLaughlin, Ernest Finkenstadt, Carl Kaiser, Robert Henry, Fred Stickle, Bob Hansen, Wilbur Bauer, and Dr. Guy Pullen.

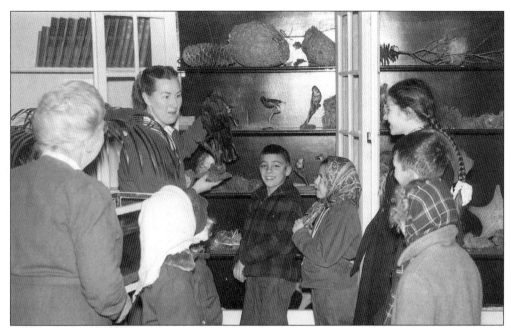

THE LEONIA YOUTH MUSEUM, 1952. A number of museum curators from the Museum of Natural History lived in Leonia, so it was fitting that one of the first youth museums in the country was formed in Leonia, in the basement of the elementary school. Dr. Selina Johnson (shown), an artist, illustrator, and teacher of comparative biology at New York University, was the director. Margaret Colbert was the curator. Dr. Frances Bartlett Tyson was the president and a major financier of the museum.

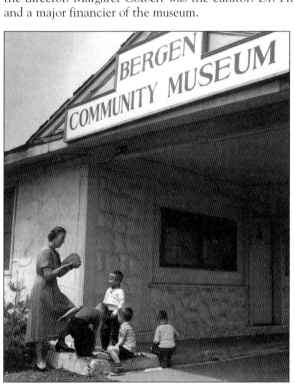

THE BERGEN COMMUNITY MUSEUM. As the collection grew, the museum struggled to find a home. The Yaldens willed their Woodridge Place home for museum use, but Leonia zoning laws prohibited it. The museum moved to this abandoned tollhouse on Fort Lee Road. After the acquisition of a mastodon skeleton, unearthed during the construction of Route 80, the museum moved to larger quarters in Paramus and became the Bergen Community Museum. Dr. Selina Johnson was affiliated with the museum for nearly 30 years.

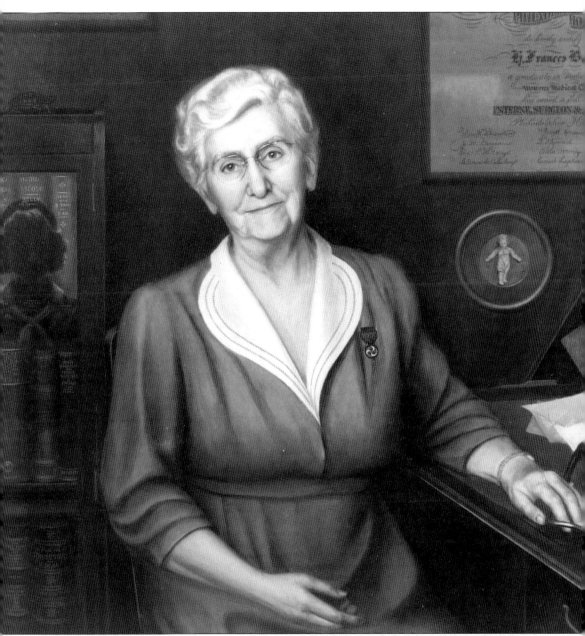

Dr. Frances Bartlett Tyson. Dr. Tyson was one of the nation's first female pharmacists (1896) and physicians (1901). She moved to Leonia in 1909 and gave up her practice at her husband's request. When the deadly flu pandemic hit Leonia in 1918, townspeople begged her to come out of retirement, as all the male physicians were serving overseas in World War I. In 1919, she discovered that a polluted spring was the source of a typhoid epidemic in town. She started the public health program in town and, until 1955, served as the school physician. She continued practicing medicine until she was 87 years old. She started the first Girl Scout troop in 1921 and helped finance the construction of their Little House. An active member of the Methodist church, she paid for the church's stained-glass windows and social room. She also donated $77,000 toward the construction of a new public library. (Portrait by David Boyd.)

GIRL SCOUTS IN FRONT OF LEONIA HIGH SCHOOL, 1949. The first Girl Scout troop in Leonia was formed in 1921. In 1944, the town had 253 girls registered. Here, the Girl Scouts and their leaders pose for a group photograph in front of Leonia High School. One of their goals was to build their own meetinghouse.

GIRL SCOUT TROOP NO. 7. Shown at the 1942 Memorial Day parade are, from left to right, Luella McPherson, a Girl Scout; her brother Fred McPherson, an air warden; and Harriette Coleman, the leader of Leonia's African American Girl Scout Troop No. 7. The 17 girls in Troop No. 7 ranged in age from 10 to 17.

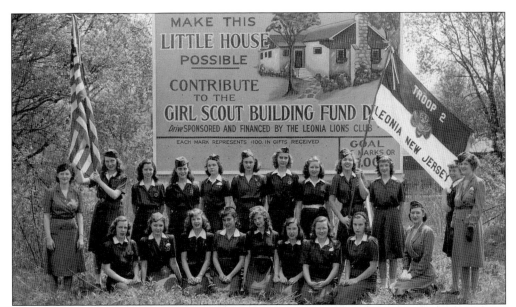

THE GIRL SCOUT'S LITTLE HOUSE, 1949. After years of fundraising, the Girl Scouts had enough money to build their own meeting place. Dr. Tyson donated a swampy plot on Broad Avenue, and local professionals combined their talents to design and build the house and landscape the property. The Little House was completed in 1951. The lower level had a kitchen and was also used for crafts and games. The upstairs, which had a stone fireplace, was used for meetings and other large group activities. In 1964, after hearing that the Greater Girl Scout Council had plans to convert Leonia's Little House into its administrative offices, the Leonia Girl Scouts sold it to the Lutheran church. In 1971, the Lutherans swapped the building, then called Holy Cross House, for a piece of borough property on Woodland Place. The Little House now serves as the municipal court, council chamber, and senior citizen center. The painting below was done by Charles Chapman.

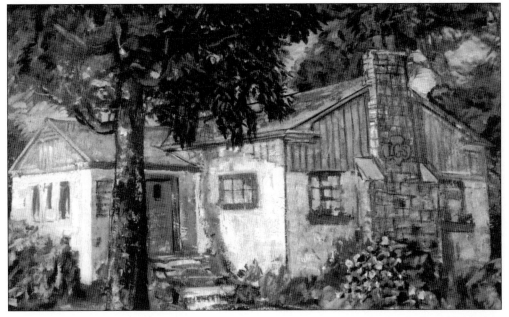

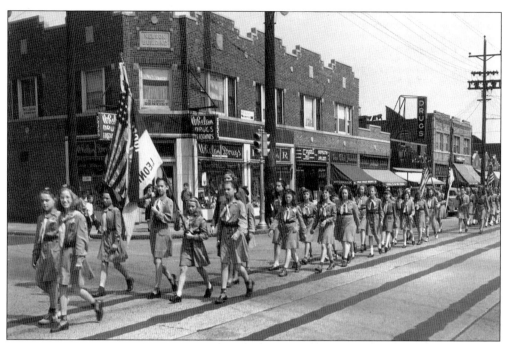

A GIRL SCOUT PARADE DOWN BROAD AVENUE, 1949. This photograph shows downtown Leonia as it appeared after World War II. Two drugstores, Lesser's and Whelan's, were within doors of each other. A longtime black resident recalled that the then owner of Lesser's Drugs would not serve black children at the soda fountain. A quiet protest resulted in the removal of the soda fountain.

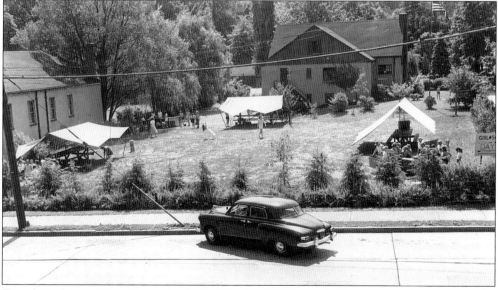

THE GIRL SCOUT DAY CAMP. In the 1950s, the Girl Scouts held a summer day camp on the lawn of the Little House. Barbecue pits were used for outdoor cooking. The lower level had a kitchen and tables for crafts and games. The upstairs, which had a stone fireplace, was used for meetings and large group activities. To the left is the American Legion hall. In 1994, the Girl Scouts started a new tradition of an overnight campout on the lawn.

MOVIE MAKING IN LEONIA. From 1902 to 1921, neighboring Fort Lee was the "movie capital of the world." Many outdoor scenes, especially for westerns with Tom Mix and chase scenes with Charlie Chaplin, were filmed in Leonia. A number of Leonians worked as extras in films. Mott Allaire, the owner of Leonia's livery stable, provided horses, buggies, and other props to the movie people. Shown is silent movie queen Priscilla Dean, who later became a longtime member of the Leonia Ambulance Corps.

THE LEONIA THEATRE. In 1927, a movie theater opened in downtown Leonia. It offered a double feature, news, an animated short film, free dishes on Thursday, and Anne Warner at the Kimball organ. In 1938, it was converted into a roller rink with a new wooden floor. In 1958, after years of disuse, Leonians voted to make it a recreation center when resident Robert Trubek offered $27,000 if the town would match his donation. It did.

THE LEONIA ROLLER SKATING RINK, 1938. "For Health Sake—Roller Skate." Promoted as "America's Finest Roller Skating Rink," the converted movie theater was open for skating every evening from 7:30 to 11:00, with John Copeland at the Hammond organ. One of the written rules was that "gentlemen must wear collars and ties." One of the unwritten rules was that African Americans were not allowed membership in this privately owned club.

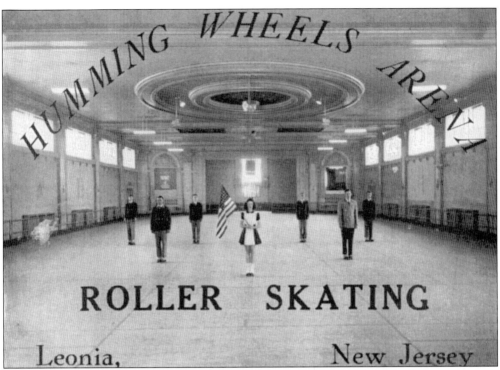

THE HUMMING WHEELS ARENA. This photograph shows the inside of the rink, with chandeliers remaining from when the building was a movie theater. The stage is still visible. The old rink continues to be used for recreational purposes—primarily basketball, exercise classes, and paddle tennis.

A ROLLER RINK DECAL. Every skater was required to show this patch to gain admission to the skating club.

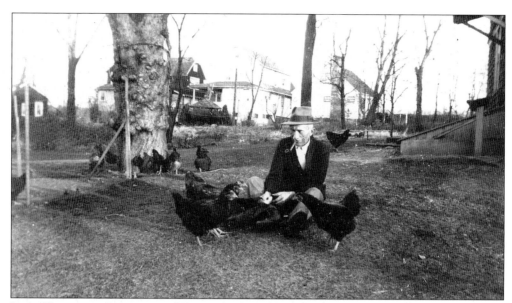

JOHN KRYHOSKI, CHAUFFEUR. The Kryhoski family emigrated from Poland in the early 20th century. They lived on the Christie Heights Street estate of Leonia developer Edward Stagg. For years, John Kryhoski was Stagg's chauffeur and gardener. In the early 1930s, Stagg died, the homestead was torn down, and apartments were built on the property. The Stagg sons kept Kryhoski on to maintain the grounds. In this 1944 photograph, Kryhoski is feeding chickens in the backyard of 201 Christie Heights Street. In the background is Hillcrest Avenue.

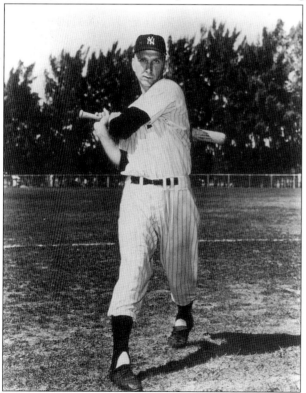

DICK KRYHOSKI, NEW YORK YANKEE. Young Leonia men frequently played ball games in the open fields at the north end of town. Leonia High School baseball star Dick Kryhoski lived right next to the high school athletic field, and neighbors recall that he was always playing catch. He was offered a contract to play first base with the Yankees in 1946, a year after his father passed away. During his professional baseball career, he played with famed players Yogi Berra, Joe DiMaggio, and Allie Reynolds.

THE RHODES FAMILY, 1937. In 1913, the Rhodes family was the first African American family to move to Leonia. Bessie O'Blenis Rhodes and William Rhodes raised six children, all of whom graduated from Leonia High School. Most of their children went on to attend Howard University. Rhodes had a barbershop on Hillside Avenue for many years. Shown are four generations of the Rhodes family at a reunion on Spring Street in 1937.

SAMUEL RHODES, TUSKEGEE AIRMAN. Born in 1921 in Leonia, Samuel Rhodes and his twin brother, Robert Rhodes, were recent Leonia High School graduates when America entered World War II. Samuel received training as a Tuskegee Airman at Tuskegee Institute. During World War II, the U.S. government still had a deeply entrenched policy of racial segregation of the armed forces. The Tuskegee Airmen, an all-black unit of the U.S. Air Force, served in Italy and Africa.

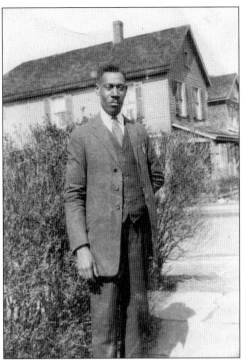

LAWRENCE COLEMAN, 96 SPRING STREET, c. 1920. In 1915, the Colemans became the third African American family to move to Leonia. Lawrence Coleman was the custodian at Leonia Elementary School for 23 years. He and his wife, Clara, had seven children, all of whom graduated from Leonia High School. Four generations of Colemans have lived in Leonia.

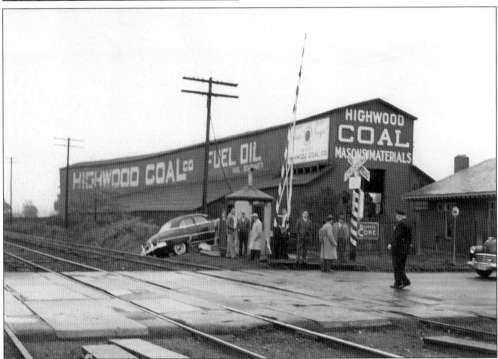

THE HIGHWOOD COAL COMPANY. For years, Leonia had a coal depot down by the railroad tracks. After the railroad station at this intersection was torn down, this larger coal depot was built. Shown is an automobile accident. In foreground is policeman "Paddy" Clarkin, who became police chief in the 1950s.

GLENWOOD AVENUE. Althea Eames Oliver is shown in front of 82 Glenwood Avenue, where she was born. In the background, on the northwest corner of Highwood and Glenwood Avenues, is the home that Nobel Prize winner Harold Urey built with his prize money. Oliver's son Wayne now lives in the Urey house. Over the years, he has collected historic postcards and photographs of Leonia, many of which were lent for this book.

THE KAMM FAMILY, 414 GRAND AVENUE. Michael Kamm was a skilled furniture craftsman who emigrated to America from Bavaria. In the 1920s, he had a workshop on Schor Avenue, where he made new furniture, restored antique furniture, and made and cleaned horsehair mattresses. In the 1920s, a number of skilled foreign-born craftsmen purchased or rented homes in the northern part of Leonia. Shown are Kamm's daughter Frieda and his wife, Marie Knopfle, on Schor Avenue.

THE OVERPECK AS A GARBAGE DUMP. Instead of becoming a marine park, as originally proposed, the wetlands surrounding Overpeck Creek became an area dumping ground in the 1940s. The stench of burning garbage and the piles of trash destroyed the pristine landscape that had lured so many to this area earlier in the 20th century. Shown here are piles of garbage behind the railroad tracks. Leonia's Sylvan Park baseball fields can be seen on the right. In 1951, Leonia ceded 127 acres to the county with the promise that the dumping would stop and a marine park would be developed.

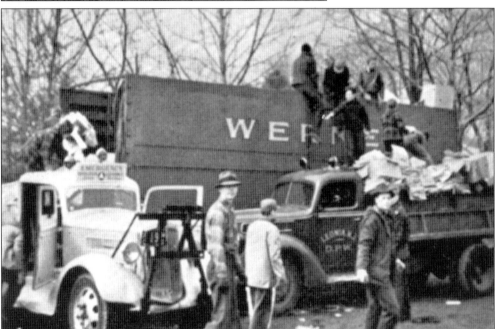

ENVIRONMENTAL ACTIVISM IN LEONIA. Recycling began during World War II, when Boy Scouts collected salvage for the war effort. In the 1970s, Leonians were among the first in the state to begin voluntary recycling. In 1967, Leonians invited Supreme Court Justice William O. Douglas to tour Highwood Hills and to support preserving it as open space. He came to Leonia, toured the woods, and gave his support. All major metropolitan newspapers covered his controversial visit.

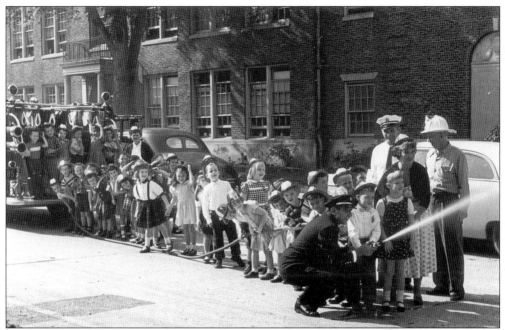

FIREFIGHTERS AT SCHOOL, C. 1955. During Fire Prevention Week, members of the Leonia Fire Department always visit the schools and discuss fire safety. Here, some excited students at Anna C. Scott School learn how to handle a hose. Students were also given rides on the fire trucks.

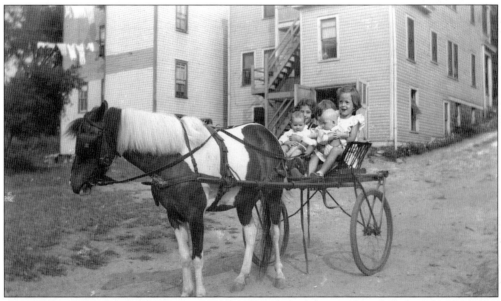

PONY RIDES. Throughout the 1950s, Leonia still had many barns where horses and ponies were boarded. The Tatro family owned a barn on Grand Avenue near Fort Lee Road. Children frequently rented horses and ponies and rode through town. Shown here is a group of children riding a cart pulled by one of Chuck Tatro's ponies. The barn and the building in the background no longer stand.

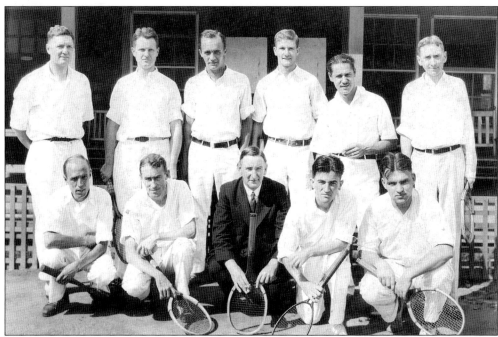

THE MEN'S TENNIS CLUB, 1920S. Tennis was clearly the favorite sport of Leonians. There were at least three tennis clubs in Leonia in the 1920s. The Leonia Tennis Club had an active membership. Seen here, from left to right, are the following: (front row) Herb Krueger, Harry Moore, Nick Dempster, and Bodet and Eddie Clark; (back row) Doc Segard, Pat Davis, John Kiehl, Dolph Vogel, George Miller, and Roy Marshall.

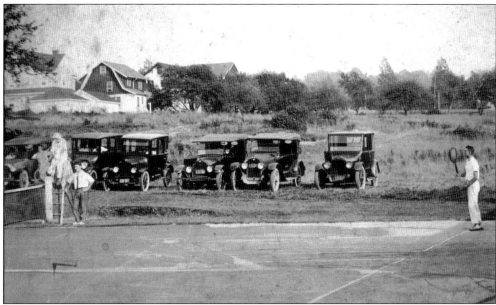

THE LEONIA TENNIS CLUB. The Oakdene Tennis Club was formed in 1910, with James V. Moore as president. It became incorporated as the Leonia Tennis Club in 1926. Tennis courts were built on the property adjacent to the Moore estate. A carriage house on the Moore property was remodeled to become the clubhouse. Note the open space on Moore Avenue.

THE CULTURAL ARTS COMMITTEE, 1969. By the 1970s, Leonia was home to many professional musicians, writers, and entertainers. Many—such as Alan Alda, an actor and director; Carmel Quinn, a singer; Freddie Bartholomew, a child star; and Robert Ludlum, an actor, producer, and author—contributed to the cultural life of the community. Others—such as singer Pat Boone, comic Buddy Hackett, and singer Sammy Davis Jr.—lived here because of its proximity to New York City. Author Robin Cook was a graduate of Leonia High School. A group of professional Leonia musicians who call themselves the Leonia Chamber Musicians has performed concerts in town for more than 30 years.

A HYMN TO LEONIA. To commemorate the 50th anniversary of the borough in 1944, residents Juline Warner Comstock and Herman C. Buhler wrote "Hymn to Leonia."